Käthe Kollwitz

The Art of Compassion

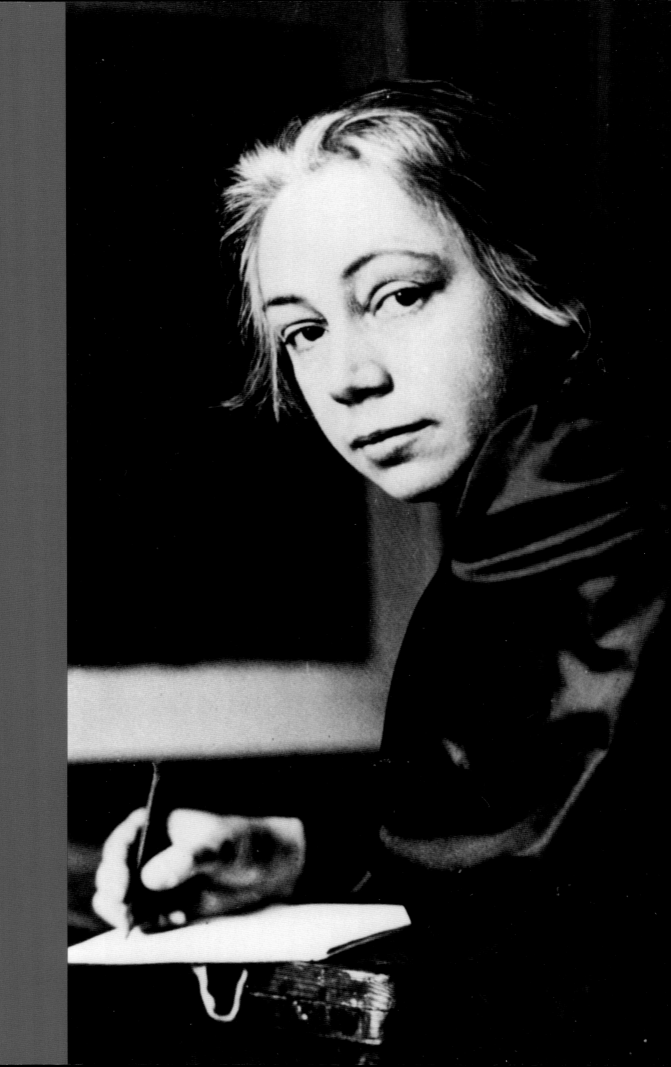

Käthe Kollwitz

The Art of Compassion

by BRENDA RIX

with an essay by JAY A. CLARKE

ART GALLERY OF ONTARIO, TORONTO

Printed and bound in Canada

National Library of Canada Cataloguing in Publication
Kollwitz, Käthe, 1867–1945
Käthe Kollwitz : the art of compassion :
March 1–May 25, 2003 / Brenda Rix ; with an essay by Jay A. Clarke.
Includes bibliographical references.
ISBN 1-894243-29-3

1. Kollwitz, Käthe, 1867–1945—Exhibitions. I. Rix, Brenda II. Clarke, Jay A. III. Art Gallery of Ontario. IV. Title.

N6888.K62A4 2003 741.943 C2002-906034-6

The Art Gallery of Ontario is funded by the Ontario Ministry of Culture. Additional operating support is received from the Volunteers of the Art Gallery of Ontario, City of Toronto, the Department of Canadian Heritage, and the Canada Council for the Arts.

Art Gallery of Ontario
317 Dundas Street West
Toronto, Ontario
Canada M5T 1G4
www.ago.net

COVER
60
Nie wieder Krieg! (Never Again War!), 1923/24
Charcoal on grey paper
65.0 x 50.0 cm
Graphische Sammlung, Staatsgalerie Stuttgart
© Estate of Käthe Kollwitz/VG Bild-Kunst (Bonn)/ SODRAC (Montreal) 2003

FRONTISPIECE
Photograph of Käthe Kollwitz, c. 1890
Käthe Kollwitz Museum Köln

INSIDE FRONT COVER
6
At the Church Wall, 1893
Etching and drypoint on wove paper
24.9 x 13.2 cm
Private collection, Toronto

INSIDE BACK COVER
39
The Prisoners, 1908
Plate 7 from *Peasants' War*
Etching, drypoint, sandpaper and soft-ground on wove paper
32.4 x 42.1 cm
AGO, gift of W. Gunther and Elizabeth S. Plaut, 1995

BACK COVER
24
Outbreak (detail), 1903
Plate 5 from *Peasants' War*
Etching, drypoint, soft-ground and aquatint on wove paper
50.8 x 59.4 cm
AGO, gift of W. Gunther and Elizabeth S. Plaut, 1995

PHOTO CREDITS
All photographs by Carlo Catenazzi and Sean Weaver except for photographs of works from the Staatsgalerie Stuttgart (cat. nos. 1, 2, 5, 7, 14-16, 20, 22, 23, 26, 38, 43, 44, 53, 59, 60, 62, 64, 66, 67), which are by Kaufmann, Stuttgart. Photographs of cat. nos. 8, 11, and 37 are by M. Simon Levy and Gary Spearin; cat. no. 72 is by Isaac Applebaum; cat. no. 5 is courtesy of the Art Gallery of Hamilton; fig. no. 1 is courtesy of the Ryerson and Burnham Libraries, The Art Institute of Chicago; frontispiece photograph of the artist is courtesy of the Käthe Kollwitz Museum Köln, Träger Kreissparkasse Köln.

Reproduction of the artworks by Käthe Kollwitz © Estate of Käthe Kollwitz/VG Bildkunst (Bonn)/SODRAC (Montreal) 2003

EDITOR
Catherine van Baren

GRAPHIC DESIGN
Marilyn Bouma-Pyper

PRODUCTION COORDINATOR
Sherri Somerville

PRINTER
St. Joseph Print Group

TYPOGRAPHY
Heads: Bureau Grotesque
Body copy: Fairfield Family

Contents

7 DIRECTOR'S FOREWORD

by Matthew Teitelbaum

9 ACKNOWLEDGEMENTS

11 PREFACE

by Brenda Rix

13 KÄTHE KOLLWITZ: "THE WOMAN WHO FEELS EVERYTHING"

by Brenda Rix

43 BEYOND BIOGRAPHY: KÄTHE KOLLWITZ AND THE CRITICS

by Jay A. Clarke

63 CHRONOLOGY

65 THE KOLLWITZ COLLECTION IN STUTTGART: A PERSONAL RECOLLECTION

by Gunther Thiem

67 CATALOGUE OF THE EXHIBITION

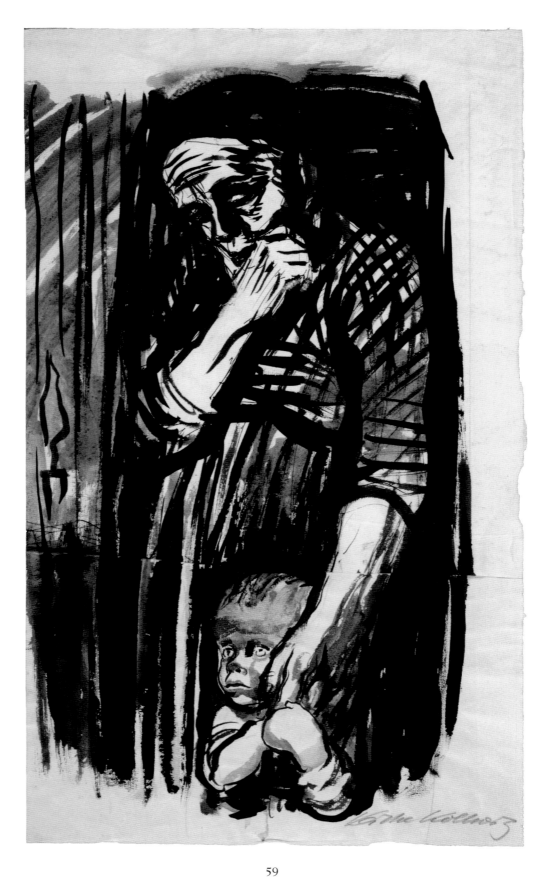

59

Standing Woman with Child
1924
Pen and black ink and wash on laid paper
48.5 x 28.5 cm.
Graphische Sammlung, Staatsgalerie Stuttgart

BY MATTHEW TEITELBAUM ART GALLERY OF ONTARIO

THERE IS A RIGHT TIME FOR EXHIBITIONS, a moment when their meaning is particularly resonant and filled with impact, when the images and ideas attach themselves effortlessly to consciousness. The work of the remarkable early twentieth-century artist Käthe Kollwitz speaks to us now of individualism and the strength of community, of suffering and survival, of mourning and hope. In a moment when the protracted horrors of world conflict seem unparalleled, in a world beset by a violence seemingly unpredictable and random, we are buffeted by Kollwitz's images of reflection and yearning. Perhaps, this is the moment to see Kollwitz again, to see her most clearly, and with all of the elemental power she intended.

Kollwitz was born as an artist from the horrors of the bloodbath that was World War I. These were terrible years for her, when she lost a son in battle and when the destructive powers of unbridled industrialism deepened her socialist inclinations. Her world seemed to fall apart, and it was through art and her belief in art that she sought to make it whole again. In *Käthe Kollwitz: The Art of Compassion* we see image after image of painfulness rendered before us, but almost always in a transaction in which one asks for and receives comfort. In much of Kollwitz's work we see figures huddled together against an unnamed force, figures finding comfort and bracing against the storm, suggesting that in community there is rebirth and, quite literally, a way to escape a numbing solitude. We see it over and over again: the enveloping embrace, the outstretched hand, the march toward the unknown in the company of others. We see a walking away *from* something as much as walking *to* something, an attempt to turn one's back on that which follows like a bad dream. In escape, there is a triumph.

For decades the work of Käthe Kollwitz has stood like a beacon to other artists. It is, for many, about the memorials we make for those we have lost and the fragility of a life we share with the living. After the Great Depression and the subsequent Second World War, there was considerable interest in Kollwitz's work in Canada, as a generation of artists, much like their counterparts in the United States, looked to respond to the sense of despair that ravaged the world. To many, at that time, art seemed spent and without conviction, whether classical or avant-garde. A social realist style of political commentary with significant narrative threads seemed a powerful

response. From European artists, Kollwitz chief among them, Canadian artists learned how social issues could be raised and the plight of the vanquished and the outsider could be recognized. These artists – in the United States, Ben Shawn, William Gropper and Raphael Soyer, and in Canada, Ghitta Caiserman Roth, Louis Muhlstock and Betty Goodwin in Montreal, Aba Bayefsky and Jack Nichols in Toronto – saw the narrative quality of Kollwitz's work as redemptive, a way of enacting a social cause that compensated for an otherwise mute response to horror. These artists from large urban centres saw their work as a response to the inequality of society, and a beacon to those left out.

The challenge was to make visible what authoritarian regimes and unbridled capitalism together had rendered invisible. Their means of representing this world, prints primarily, but also paintings with a strong linear composition, paid their debt to Kollwitz. Dramatic shadings, references to social interaction, individuals seeking community to grapple with life's challenges – these were the connections that artists made with Kollwitz. This commitment to effect change through art, this belief that images could influence behaviour, were subsequently reflected in the work of such image-makers today as Leon Golub, Sue Coe and, in Canada, John Scott. Art expresses an urgent belief in change. Art, in the act of making it, is a response to the helplessness and muteness of the individual.

Kollwitz's art encourages reflection and pause. Her unforgettable images suggest that we reach into the sadness at the core of contemporary life and pull from it the vestige of hope and belief in the future. Her example inspires us still. ∎

Matthew Teitelbaum
DIRECTOR, ART GALLERY OF ONTARIO

Acknowledgements

THE EXHIBITION AND ACCOMPANYING CATALOGUE have been made possible through the collaboration of many people. Ulrike Gauss, curator of the Graphische Sammlung, Staatsgalerie Stuttgart, supported the project from the beginning, and the scope and quality of the contents of the exhibition were greatly enhanced when we secured the loan of thirty remarkable drawings from Stuttgart. Gunther Thiem, who was instrumental in building the Kollwitz holdings in Stuttgart, has provided an account of the history of the collection.

A number of other individuals have been very generous: scholars Hildegard Bachert, Barbara Butts and Elizabeth Prelinger provided valuable information and advice. Judy Scolnik assisted in tracking down Kollwitz works in local collections. Leonore Jenkner translated several difficult passages in German.

At the Art Gallery of Ontario, Matthew Teitelbaum, director, took a personal interest in the exhibition and Katharine Lochnan, senior curator, Prints and Drawings, provided guidance and direction at crucial junctures in the development of the exhibition contents and thesis.

Staff members in departments across the Gallery had a hand in the realization of either the exhibition or the catalogue and it is impossible to thank them all individually. Special thanks go to Jill Cuthbertson, manager, Exhibitions and Photographic Resources, for her overall coordination of the project. Various members of the staff of prints and drawings have assisted over the past three years; in particular, administrative assistant, Lise Hosein, and interns Jessica Morden and Rosa Berland. Thanks also go to Catherine van Baren, editor, for her sensitive editing of the manuscript, and to Marilyn Bouma-Pyper, graphic designer, for the dynamic design of the catalogue. John O'Neill, Joan Weir and Ralph Ingleton in conservation, George Bartosik, and the Exhibition Services staff, and Faye Van Horne and the Photographic Resources staff, have played key roles as the project developed.

The exhibition was also made possible through the good will of staff at other Ontario museums. These include Pierre Théberge, director, and Delphine Bishop, chief of Collections Management, National Gallery of Canada; Louise Dompierre, director, Tobi Bruce, curator, and Christine Braun, registrar, Art Gallery of Hamilton; and Kim Ness, director and curator, and Gerrie Loveys, collections and operations manager, McMaster Museum of Art.

Lenders to the exhibition have been exemplary in their support. Along with three lenders who wish to remain anonymous, our gratitude is extended to Ronald and Maralyn Biderman, David and Anita Blackwood, Raymond and Yolanda Burka, Ramsay and Eleanor Cook, Mark and Judy McLean, Carol and Morton Rapp, Barry Callaghan, Nina Callaghan, Edith Layne, Louis Myers and Claire Weissman Wilks.

Finally, it has been a pleasure to work with Jay A. Clarke, associate curator of Prints and Drawings at the Art Institute of Chicago. Jay's enthusiasm for the subject has been contagious; she has provided countless suggestions along the way, and has written a fascinating essay that includes unpublished material from her thesis. Together, we have found the research on this project to be most rewarding and the art of Käthe Kollwitz to be truly inspirational. ∎

Brenda Rix

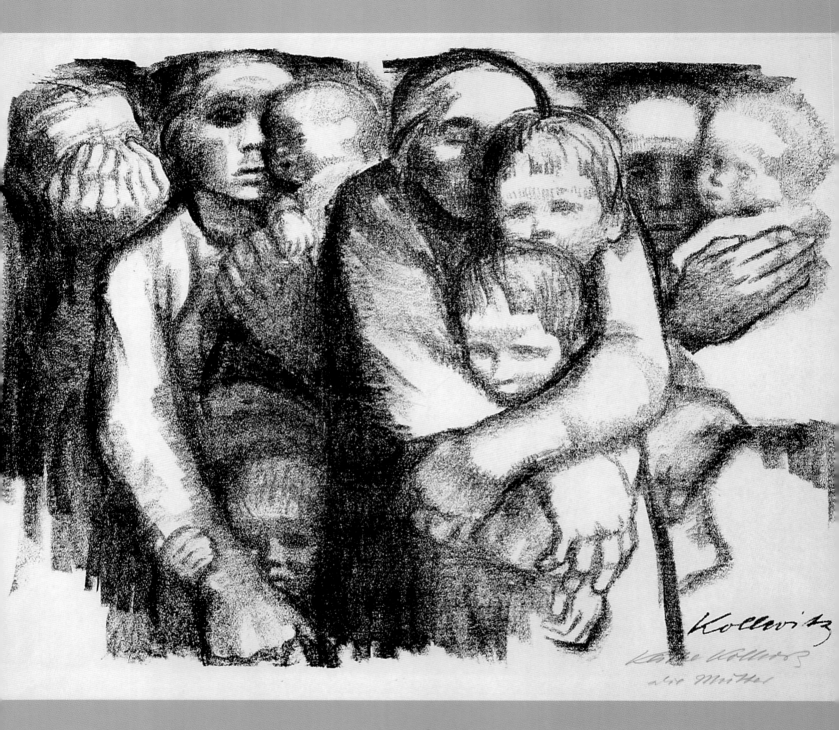

49

Mothers
1919
Transfer lithograph on wove paper
52.2 x 62.9 cm (sheet)
Art Gallery of Ontario, gift of W. Gunther and
Elizabeth S. Plaut, 1995

Käthe Kollwitz: The Art of Compassion is a timely celebration of the wealth of the artist's work in Ontario public and private collections, and a rare opportunity to showcase a group of outstanding drawings from the Staatsgalerie Stuttgart, Germany. In the late 1970s an exhibition of Käthe Kollwitz's prints and drawings travelled across Canada under the auspices of the Goethe Institut and was shown at the Art Gallery of Ontario in 1978. The last major Canadian-organized exhibition of the artist's work originated at the National Gallery of Canada in Ottawa in 1963 and was shown in Toronto in the Fall of that year. Given the interest in Kollwitz's work among Canadian artists and collectors, a presentation of the powerful images of this leading twentieth-century German artist is long overdue.

In 1995 the Art Gallery of Ontario received a generous gift of nine Kollwitz prints from Rabbi Gunther Plaut of Toronto. As a young man in the 1920s and 1930s, Rabbi Plaut remembers encountering the artist on daily walks around the streets of Berlin. He had great admiration for the older woman and brought his enthusiasm for her work and some of her prints with him when he moved to North America. Among this group were impressions of several monumental etchings from the *Peasants' War* series. Our desire to exhibit this special gift led to the initial plans for the exhibition.

In 1998 a visit to the Staatsgalerie in Stuttgart provided the opportunity to study the Kollwitz holdings in the Graphische Sammlung (Print and Drawing Collection). I found a group of drawings of the highest quality – full of vitality, technically complex and profoundly moving. That experience marked the beginning of negotiations to borrow these drawings for our exhibition.

In the past three years, an investigation of local collections yielded surprising results. A large number of prints, drawings and sculptures were discovered in private Toronto collections in addition to public museums across the province. Unfortunately it was necessary to whittle down the list and request only about half the works for the exhibition that were potentially available for loan.

The preparation and organization of the exhibition has been a journey of discovery and revelation. The treasures found in local collections were selected to complement the Stuttgart drawings, resulting in an exhibition that provides a chronological and thematic overview of the artistic development of Käthe Kollwitz, a woman of strength who created an art of compassion. ∎

Brenda Rix
ASSISTANT CURATOR, PRINTS AND DRAWINGS
ART GALLERY OF ONTARIO

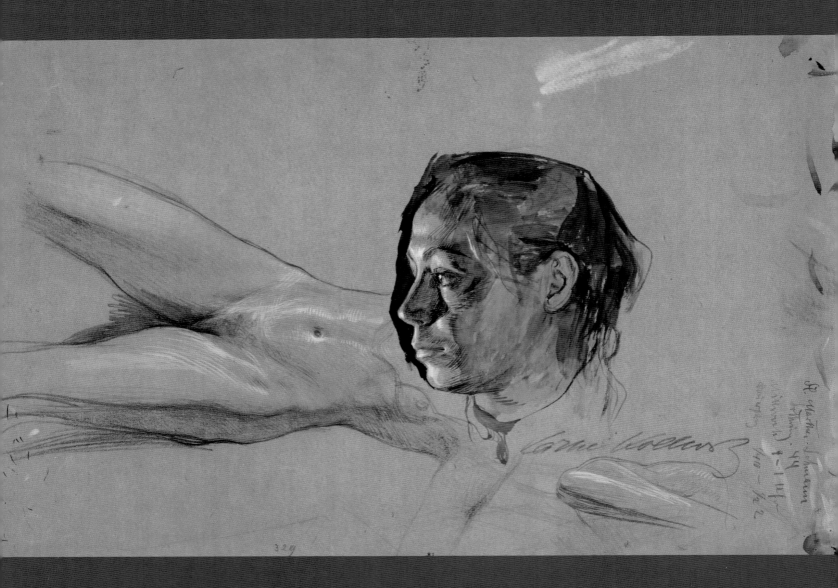

14

Self-Portrait with Nude Studies
1900
Pen and black ink with wash over graphite heightened
with white on brown paper
28.0 x 44.5 cm (irregular sheet)
Graphische Sammlung, Staatsgalerie Stuttgart

Käthe Kollwitz

"The woman who feels everything"

BY BRENDA RIX ART GALLERY OF ONTARIO

IN A DIARY ENTRY DATED JANUARY 12, 1920, Käthe Kollwitz writes of "the woman watching, who feels everything," a lone figure who appears in the background of one of her lithographs. She could be describing herself, observing the tragedies of life, listening and seeing "the suffering of the world."[1] In the course of a career lasting over fifty years, Kollwitz remained aloof from major art movements such as German Expressionism and abstraction. Her art was intensely personal, autobiographical and rooted in socialist thought and practice. She was concerned about form as much as content and said that she sought to "extract the emotional content out of everything, to let things work upon [her] and then give them outward form."[2]

Kollwitz's art was essentially figural; her preferred subjects were female. Her interest in the lives and fates of women, especially working-class women, is evident in even her earliest works. Eventually, she focused almost exclusively on the plight of proletarian women, who became the vehicles through which she explored such themes as motherhood, oppression, death, war and sacrifice. The following essay and accompanying exhibition are organized around these prevailing thematic groupings.

Königsberg and Early Influences

Käthe Kollwitz (1867–1945) was born Käthe Schmidt and grew up in a liberal-minded, religious family in the town of Königsberg in East Prussia. Her maternal grandfather, Julius Rupp, founded the Protestant Free Religious Congregation, a breakaway group from the state-controlled Lutheran Church. Julius Rupp is quoted as saying, "Man is not here to be happy but to do his duty" and that "Every gift is a responsibility."[3] At her grandfather's death, her father, Karl, who was trained as a lawyer but worked as a stonemason, became the minister of the church. Her father, her brother, Konrad and Konrad's friends, including her future husband, Karl Kollwitz, were members of the German Social Democratic Party.

Grounded in a value system that extolled humanitarian and socialist views, Kollwitz's art also reflected the events of her own life. The autobiographical element in her work is unavoidable, as her preoccupation with making self-portraits attests. Her marriage to a medical doctor in 1891, and their life among the working class in the slums of Berlin, gave her profound insights into the daily existence of women facing unbearable living conditions, unemployment, poverty and disease. The birth of her two sons is related to her fascination with the subject of motherhood. The tragic death in World War I of her younger son Peter added fresh poignancy to the themes of loss, death and sacrifice, which had already been explored in her work.

In 1941 Käthe Kollwitz recalled that "From my childhood on my father had expressly wished me to be trained for a career as an artist, and he was sure that there would be no great obstacles to my becoming one."[4] Despite her father's optimism, there were a number of obstacles to be overcome before she reached her goal. Even early on, gender limited her opportunities. Women were not admitted to the official art academies, thus she trained in Königsberg with private teachers – first the engraver Rudolf Mauer and later with Emil Neide. At the age of seventeen she attended the Berlin Women's Art Union, where she studied with Karl Stauffer-Bern, a progressive instructor, who recognized her outstanding ability to draw and encouraged her to give up oil painting and pursue drawing and printmaking.[5]

4

Tavern in Königsberg
1890–91
Pen and black ink and grey
wash on wove paper
24.8 x 32.8 cm
Art Gallery of Ontario,
purchase, 1983

Commitment to Drawing and Printmaking

It was natural for Kollwitz to be attracted to a democratic medium like etching which could make her work accessible and affordable to a wide audience. The possibility of printmaking as a vocation was reinforced by her contact with the etchings and writings of Max Klinger. In 1884 she saw Klinger's series *A Life* (Ein Leben) at a Berlin exhibition and "it excited [her] tremendously." The socially biting subject matter, inspired by French Naturalism, attracted the young Kollwitz.[6] These themes, along with the narrative sequence of the series, the technical aspects of Klinger's prints, and his theories about the "imaginative" potential of the "graphic arts" over painting would become formative influences on Kollwitz's art.[7]

Never forgetting her grandfather's admonition that a gift or talent was a responsibility, Kollwitz was committed to maintaining high standards, including technical excellence in printmaking. She constantly experimented with new techniques. Beginning in the early 1890s with etching, she expanded into soft-ground etching, aquatint and various other tonal processes including lithography from 1895 to 1910, lithographic colour printing from 1899 to 1903, and woodcut in the early 1920s. From the mid-1920s to the end of her life she chose lithography as the medium to best express the painful themes of those years in a direct and forceful manner.[8] She worked hard to increase the emotional and visual impact of her images by omitting the "inessentials."[9]

Kollwitz saw drawing as a vital step in the creative process and the foundation of her work in printmaking and later in sculpture. She used drawing to develop ideas (cat. nos. 14, 23), to

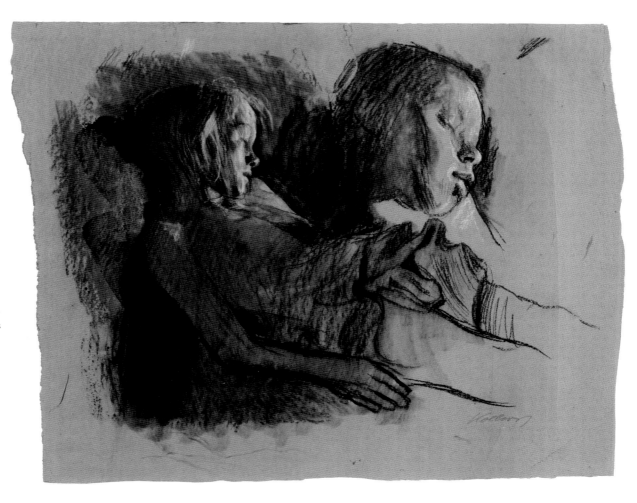

23

Sleeping Child and Child's Head
1903
Charcoal, pen and black ink, green pastel, white highlights on grey-brown paper
51.0 x 63.0 cm
Graphische Sammlung, Staatsgalerie Stuttgart

15

Man Kneeling before a Female Nude Seen from behind
c. 1900
Charcoal and blue chalk heightened with white
64.0 x 50.1 cm
Graphische Sammlung, Staatsgalerie Stuttgart

I

*Sheet of Head Studies
(Women)*
1890/91
Pen and ink and wash on laid
paper
30.7 x 47.5 cm
Graphische Sammlung,
Staatsgalerie Stuttgart

43

*Woman Seated
on the Ground*
1910/11
Charcoal on greenish grey
paper
46.8 x 65.5 cm
Graphische Sammlung,
Staatsgalerie Stuttgart

practise the basics (cat. nos. 1, 3), to work out compositional arrangements (cat. nos. 4, 20, 21), and to create finished works of art (cat. nos. 7, 16). Studies of hands, faces and nudes (cat. nos. 1, 3, 15, 30) proliferate in her early works, confirming the centrality of the human figure to her artistic vision.[10] As she eliminated more and more distracting details of setting and costume, she retained three essential building blocks: the faces, hands and bodies of the figures. These are modified and reworked to create the expressive and emotional import of her deceptively simple images. By 1909 she could write that, "As a result of so much working on studies I have at last reached the point where I have a certain background of technique which enables me to express what I want without a model."[11]

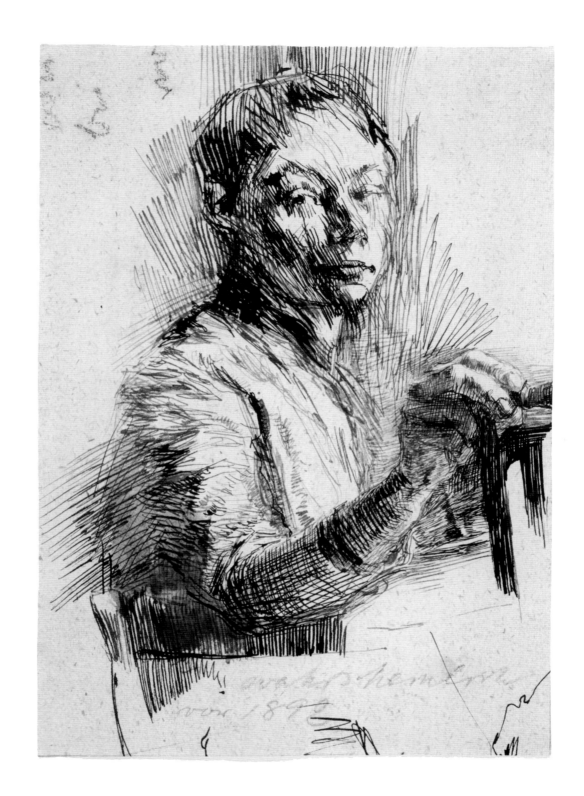

2

Self-Portrait, Drawn in Half-Profile to the Right
1891/2
Pen and black ink and wash over
graphite on wove paper
20.4 x 14.1 cm
Graphische Sammlung, Staatsgalerie Stuttgart

Kollwitz by Herself

Self-portraits appear at almost every stage of Kollwitz's career and can be counted as some of her most compelling images. Among her earliest recorded drawings and prints are those of her own face (cat. nos. 2, 5).[12] These early works are carefully delineated in pen and ink or etched line and tend toward the illustrative. She developed a brooding, thoughtful persona, presenting herself as a serious artist, seated at a desk with the accoutrements of her trade — pencil, paper and working lamp. In pose, setting, and lighting these works owe much to the mature self-portrait etchings of Rembrandt.[13]

Throughout her life, Kollwitz obsessively portrayed herself in a variety of media. She is usually shown full face but sometimes looking to the side and occasionally in profile; the position of her hand is critical, often to her chin, her cheek or shielding her eyes. This pose is related to the conventions of melancholy going back to Albrecht Dürer's engraving *Melancholia* and traditionally speaks of the inspired genius, or perhaps a seer or thinker. A melancholic pose and gaze is also found in self-portraits by other artists of the period.[14] In Kollwitz's later self-portraits, setting and accoutrements are eliminated, making the face, often with the hand to the brow, the central, monumental, even iconic focus of these images (cat. nos. 68, 52, illus. p. 62).[15]

Also working in the tradition of Rembrandt who often portrayed himself in his historical paintings, Kollwitz uses her own face in narrative images, beginning with early subjects such as *Young Couple* (cat. nos. 7, 31, illus. pp. 22–23). Over and over, the same recognizable, almost androgynous, facial features appear in works like *Municipal Shelter* (cat. nos. 64, 65, illus. p. 29) and *Thinking Woman* (cat. no. 51), emphasizing again how deeply and intimately she identified with the pain of her subjects.

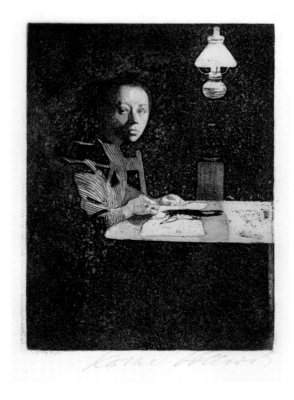

5

Self-Portrait at a Table
1893
Etching, drypoint, and aquatint on wove paper
17.8 x 12.8 cm (imp.)
Art Gallery of Hamilton, gift of Mr. G.C. Mutch in
memory of his mother, Annie Elizabeth Mutch, 1959

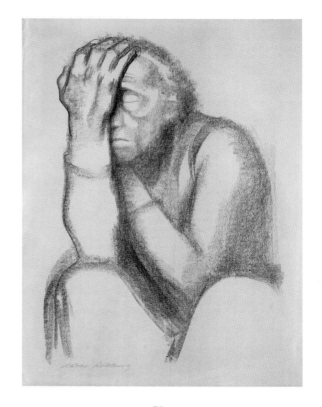

51

Thinking Woman
1920
Transfer lithograph on wove paper
59.8 x 44.3 cm (sheet)
Art Gallery of Ontario, gift of Carol and
Morton Rapp, 2002

Motherhood

Following the birth of her sons – Hans in 1892 and Peter in 1896 – Kollwitz documented her ongoing fascination with motherhood in many works.[16] Various phases of motherhood are explored: pregnancy (cat. nos. 42, 66), bonding of mother with infant/child (cat. nos. 45, 67), motherly protection of the young (cat. nos. 58, 59), the pain of separation through death (cat. nos. 26, 27, 41, 44, 74), the bond between mothers (cat. nos. 49, 66), and less frequently, images of happy mothers and babies (cat. no. 67).

In late nineteenth-century Germany being a wife/mother and being a professional artist were deemed to be mutually exclusive. As evidenced by her diary entries, Kollwitz struggled with conflicting demands on her time; however, like the emotionally draining relationship she had with the desperate women she encountered every day, it was within these deeply felt experiences that she developed her intense drive, her passion to create. When her children were away and she had time to work, she found herself at loose ends and unproductive.[17]

Her strong commitment to her family did not lessen her dedication to her art or prevent her from attaining success as an artist. In 1898 she was invited to teach drawing and etching classes at the Berlin Women's Art Union, where she had been a student.[18] In 1899 she began to exhibit with the Berlin Secession, a group of independent, predominantly male artists of diverse artistic persuasions. In 1919 she became the first woman professor at the Berlin Academy of Art, an institution that now permitted female students. In 1928 she was made the director of the graphics studio at the Academy. She was at the height of her career in the 1920s, and had several exhibitions of her work, including a major exhibition in the Soviet Union in 1927.

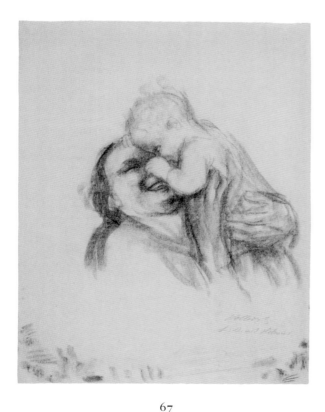

67

Mother with Child in Her Arms
1931/32
Charcoal on brown laid paper
63.0 x 49.0 cm
Graphische Sammlung,
Staatsgalerie Stuttgart

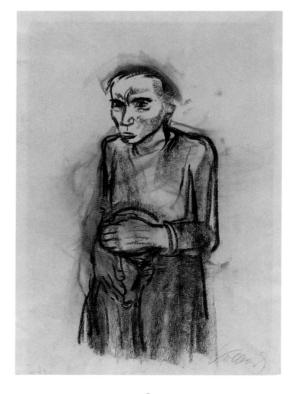

58

Standing Woman Clutching Child
c. 1924
Charcoal on tan laid paper
48.3 x 32.2 cm
Private collection, Toronto

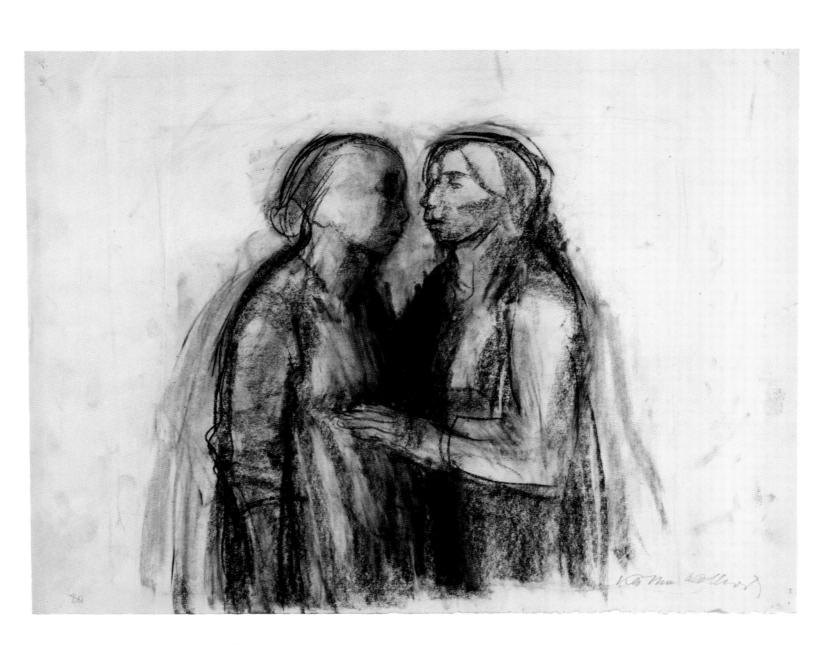

66

Mary and Elizabeth
1926–27
Charcoal on cream paper
38.5 x 50.5 cm
Graphische Sammlung, Staatsgalerie Stuttgart

Early Narrative Themes and "Naturalism"

Given her background in socialism, it is not surprising that Kollwitz gravitated early on to a realistic or naturalistic style in art. Naturalism in literature and art, as it gained prominence in France in the nineteenth century, generally referred to making a record of the unidealized everyday lives of working-class people. In the 1880s and 1890s many young German writers and artists came under its influence. Closely linked to the novels of the French author Émile Zola and the paintings of Edouard Manet and Gustave Courbet, Naturalism was considered unpatriotic by conservative German critics, who felt it was ugly, trivial and lacking imagination.[19]

Kollwitz was well read and drew on a large repertoire of literary sources for her themes, including historical narratives, modern fiction, poetry and drama. Members of her social circle particularly appreciated the work of Zola and other Naturalist writers. One of her first etchings was for Zola's *Germinal*, a novel that had caused a sensation when it was published in 1885 and told the story of a young miner who incited his fellow workers to strike. Kollwitz's drawing *Tavern in Königsberg* (cat. no. 4, illus. p. 14) of 1890 was a study for the etching and shows "where two men fight in the smoky tavern over young Catherine."[20]

Other early prints and drawings similarly focus on the fates of young women caught in tragic personal relationships. In one of several prints inspired by Kollwitz's favourite author, Goethe, Gretchen, from his play *Faust* is shown in a moment of great distress in *At the Church Wall*, 1893 (cat. no. 6, illus. p. 45). She leans woefully against the church wall, hand covering her face in despair, following the discovery of her unwanted pregnancy by Faust. An impression of this print was shown at the exhibition where Kollwitz received her first critical attention, along with the drawing *Young Couple* of 1893 (cat. no. 7) based on Max Halbe's play *Youth*.[21] *Young Couple*

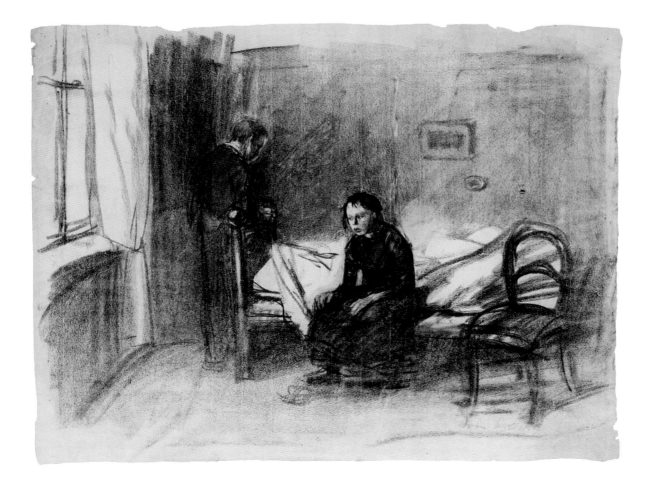

7
Young Couple
1893
Charcoal on grey laid paper
43.0 x 55.0 cm (irreg.)
Graphische Sammlung,
Staatsgalerie Stuttgart

explores the strained relationship between a young couple following a sexual encounter and an unexpected pregnancy. A kind of modern day *Romeo and Juliet*, the story was set in a working-class context. There were repercussions for choosing such Naturalist themes in pre-war Berlin – their portrayal in the 1890s would have been perceived as "socialist, even anarchist statements to the critics." [22]

These early images, which focus on the tragedies of victimized heroines in novels and plays, can also be explored in light of Kollwitz's early attraction to working-class subjects. She remarked that she was first attracted to the "worker" theme during her youth in Königsberg, where she observed and drew the workers on the streets and at the docks. In a much-quoted statement, she said she found them "beautiful....the proletariat...had a grandness of manner, a breadth to their lives." [23] She developed a much better grasp of the magnitude of their problems by the early 1890s. From 1891, when she married the physician Karl Kollwitz, and for the next fifty years, she lived in a small apartment in the densely populated tenements of Berlin and came face to face every day with "the full force of the proletarian's fate" and particularly with the fate of lower-class women. [24]

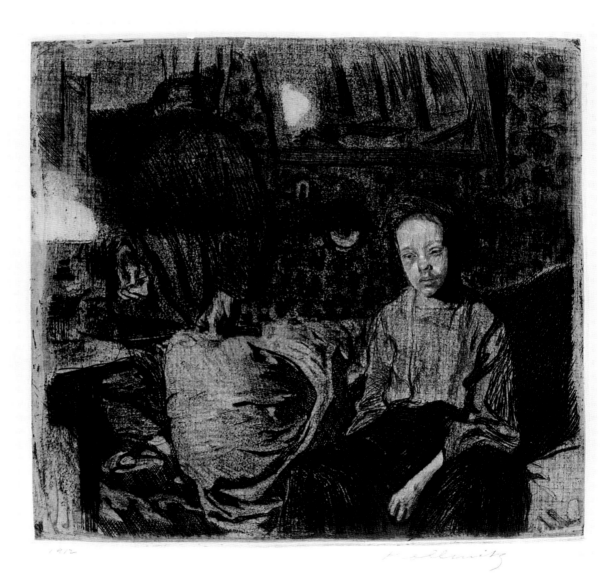

31

Young Couple
1904
Etching and soft-ground
on wove paper
29.8 x 31.6 cm (imp.)
Collection of David and
Anita Blackwood

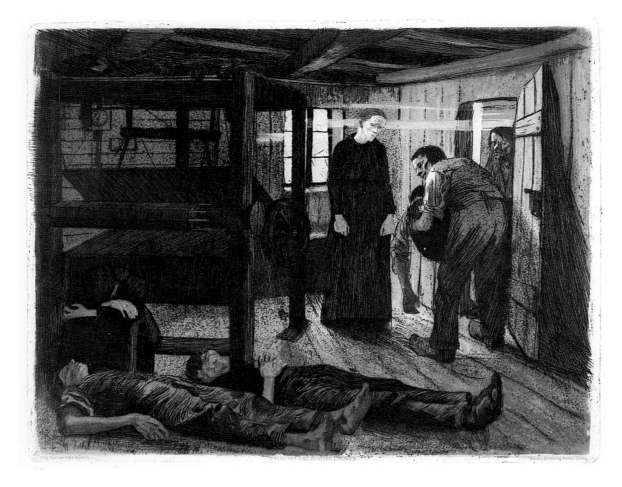

II

End
1897
Plate 6 from *A Weavers' Rebellion*
Etching, aquatint and sandpaper
on cream wove paper
23.6 x 30.0 cm (imp.)
McMaster University
Collection, Hamilton

"A Weavers' Rebellion" and "Peasants' War": Victims in Revolt

By the mid-1890s Kollwitz was ready to bring together her knowledge of the realities of workers' lives, her background in socialism, and her interest in naturalistic themes, with a bold exploratory approach to printmaking. Her first major print series, *A Weavers' Rebellion*, begun in 1893, was inspired by attending a performance of Gerhart Hauptmann's new play, *The Weavers*. Like the play, Kollwitz's images were loosely based on a notorious revolt of Silesian workers against oppressive landlords in 1844.[25]

As Kollwitz sought her way technically, she rejected several trial attempts at etching and lithography. She considered the lithographs to be less successful than the etchings but included three lithographs and three etchings in the final selection.[26] These dramatically lit, highly charged scenes are drawn with confident, open strokes. *A Weavers' Rebellion* (cat. nos. 8–11) caused a sensation when exhibited in 1898 at the Great Berlin Art Exhibition and was nominated for a gold medal. The awarding of the medal was vetoed by the Prussian Emperor Wilhelm II because Kollwitz was a woman, because her technique was naturalistic and her subject matter was too provocative in light of current worker unrest (see Jay A. Clarke, pp. 47–49). [27]

As in so much of her work, Kollwitz protests against oppression and suffering not by showing the oppressor but by focusing on the experiences and reactions of the victims. In Kollwitz's version of the weavers, however, the women are not merely victims. They appear in five of the plates and are shown to be full participants in the drama. Images such as *The Weavers' March* (cat. no. 9, illus. p. 46) speak eloquently of the strength to be found in solidarity among human beings. In *End* (cat. no. 11) two woman are shown in a dark interior, receiving the dead bodies of the strikers. One is collapsed in grief, while the other stands stiffly by the doorway with fists defiantly clenched.[28]

19

The Carmagnole
1901
Etching, drypoint, aquatint
and sandpaper on wove paper
57.8 x 45.0 cm (imp.)
Art Gallery of Ontario,
purchase, 1983

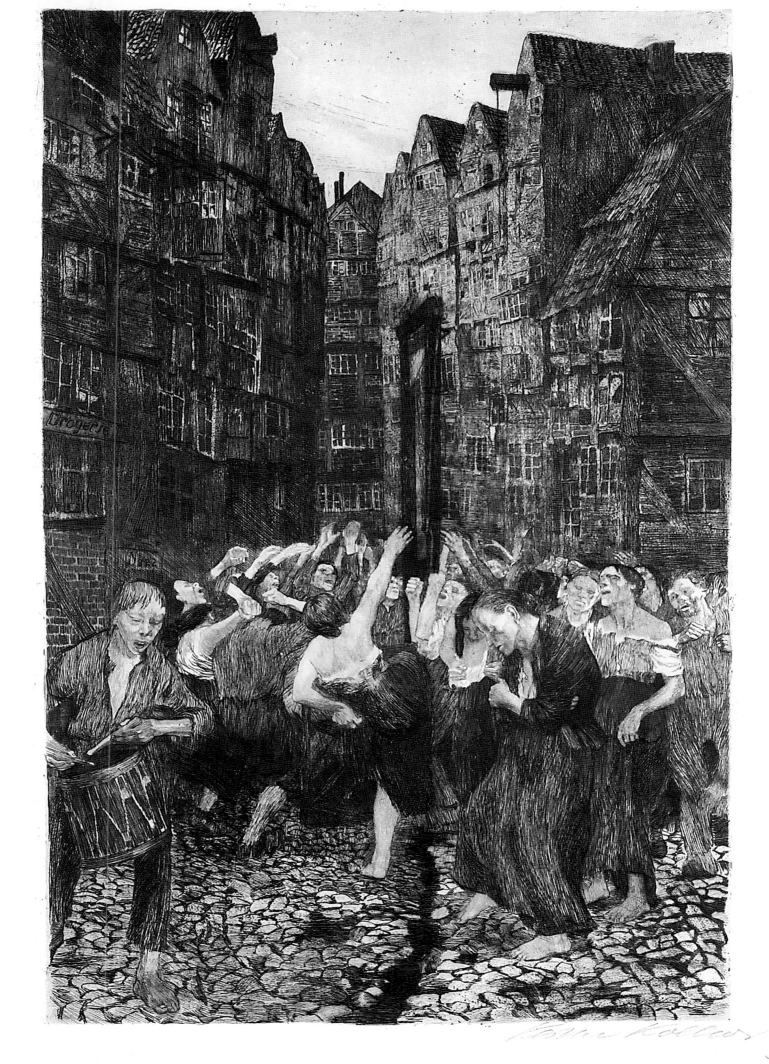

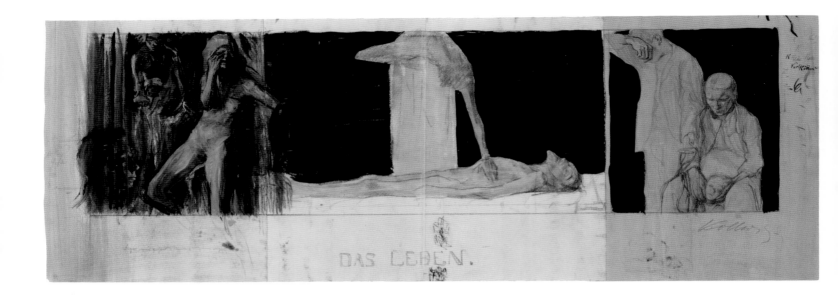

Kollwitz originally intended the series to end with a highly symbolic print titled *The Downtrodden* of 1900 (cat. nos. 17, 18). This iconographically complex image, illustrated by the working drawing *Life* (cat. no. 16), deals with issues of prostitution, suicide and poverty set in a traditional Christian Lamentation format.[29] Kollwitz became convinced that this kind of symbolism was not an appropriate conclusion to the gritty narrative of the weavers.

Following the acclaim and notoriety she received from the publication and exhibition of her first series, Kollwitz produced a number of other ambitious etchings in a similar illustrative vein. *The Carmagnole* (cat. no. 19) of 1901, for example, was inspired by the Charles Dickens novel *A Tale of Two Cities*, and shows women dancing around the guillotine in celebration of the French Revolution. In *Uprising* (cat. no. 13, illus. p. 57) an allegorical female nude flies overhead urging the revolting peasants to march onward.

Kollwitz took up the powerful theme of violent revolution again in her second and most ambitious print series published in 1908. *Peasants' War* was inspired by her reading of Wilhelm Zimmerman's history of a sixteenth-century German peasant uprising.[30] The overall approach was less illustrative than *A Weavers' Rebellion*. The seven large plates of the *Peasants' War* (cat. nos. 24, 33–39) show a dramatic stylistic evolution toward greater simplicity and concentration of pictorial means. They are technical tours de force, prepared using a wide range of intaglio processes. The imagery is similarly radical, disturbing in content and monumental in presentation.[31]

Again, the experience of women is central in *Peasants' War*, and again they are the victims of oppression. But unlike *A Weavers' Rebellion*, where women participate in the revolt, here they take the lead in the revolution. In the print *Sharpening the Scythe* (cat. no. 33, illus. p. 52) a diabolical, slit-eyed woman prepares for battle. In *Outbreak* (cat. no. 24) the historical figure Black Anna incites the peasants to riot. Black Anna has been characterized by one writer as the "visual manifestation of women's energy, self-assertion and power."[32] By placing her in the foreground and portraying this large, lunging figure from the back, Kollwitz identifies herself and the viewer with this powerful woman.[33] Although she would later "shy away from the role," Kollwitz states, "I was a revolutionary – my childhood and youthful dream was revolution and barricades."[34]

16
Life
1900
Left: pen and black ink and wash heightened with white on white laid paper; Centre: black chalk over graphite with grey wash on white laid paper;Right: black chalk and graphite with pen and black ink and wash on brown paper
32.5 x 92.9 cm
Graphische Sammlung, Staatsgalerie Stuttgart

OPPOSITE
24
Outbreak
1903
Plate 5 from *Peasants' War*
Etching, drypoint, soft-ground and aquatint on wove paper
50.8 x 59.4 cm (imp.)
Art Gallery of Ontario, gift of W. Gunther and Elizabeth S. Plaut, 1995

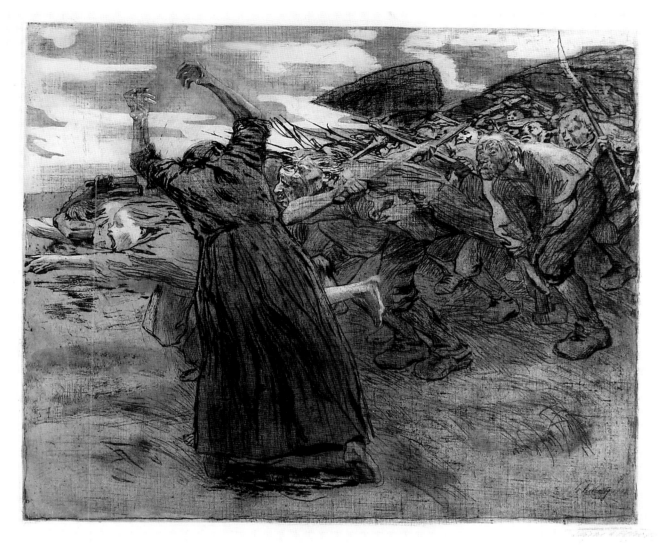

24

38
Study of Peter for "Prisoners"
1908
Graphite on brown paper
46.9 x 65.5 cm
Graphische Sammlung, Staatsgalerie Stuttgart

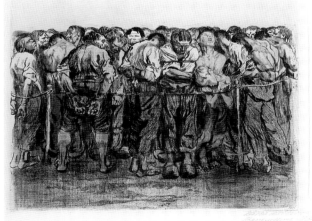

39
The Prisoners
1908
Plate 7 from *Peasants' War*
Etching, drypoint, sandpaper and soft-ground on wove paper
32.4 x 42.1 cm (imp.)
Art Gallery of Ontario, gift of W. Gunther and
Elizabeth S. Plaut, 1995

War and Sacrifice

The content of Kollwitz's two early print series and, indeed, all her work before World War I, reflect her conviction that revolution, war and sacrificing one's life may be necessary to achieve a greater good. Such idealistic views were challenged by the death of her son Peter in 1914. Her grandfather's saying about putting duty above happiness would then come back to haunt her. After a long, agonizing struggle, which is documented in her diaries and letters, she confronts her betrayal of Peter and his patriotism, deciding that there is no justification for war or the horror of losing not only her own son but all of the country's sons. In the end Kollwitz became a confirmed pacifist.

Kollwitz was most socially active during the 1920s and 1930s. No longer content to speak out against injustice and poverty in a general way through the vehicle of historical narratives, she addressed current issues directly, designing leaflets and posters such as the famous *Never Again War!*, 1924 (cat. no. 60, illus. cover), commissioned for the Central German Youth Day in Leipzig. *Municipal Shelter* (cat. nos. 64, 65) documents the situation of the homeless and unemployed and *Home Worker* (cat. no. 63) protests the low pay and poor living conditions of piecework labourers.[35]

Her *Memorial Sheet to Karl Liebknecht* (cat. no. 50) was a politically provocative statement in a stark, black-and-white woodcut. Liebknecht was the leader of an anti-government, extreme left-wing movement who, along with his co-leader, Rosa Luxemburg, was murdered on January 15, 1919. Although Kollwitz did not adhere to his radical politics, she agreed to Liebknecht's family's request to commemorate his violent death. She developed this conception over the period of a year in several drawings, two intaglio prints and a lithograph before arriving at the final woodcut. In 1919 a visit to an exhibition of prints by Ernst Barlach provided the impetus to turn to woodcut. She realized that this technique, traditionally associated with popular broadside prints, allowed for an immediacy suited to the horror of the subject.

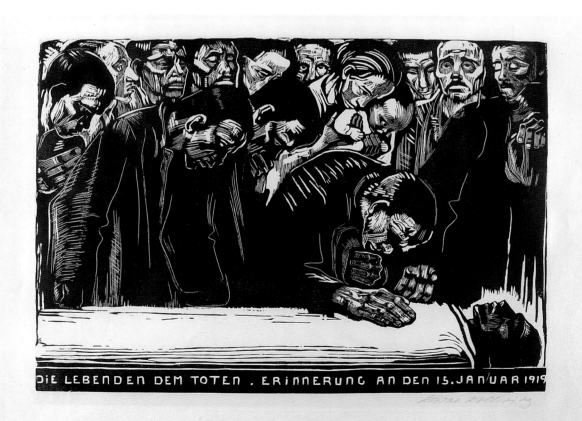

50

*Memorial Sheet
to Karl Liebknecht*
1919–20
Woodcut on wove paper
35.3 x 49.4 cm (image)
Collection of Ronald and
Maralyn Biderman

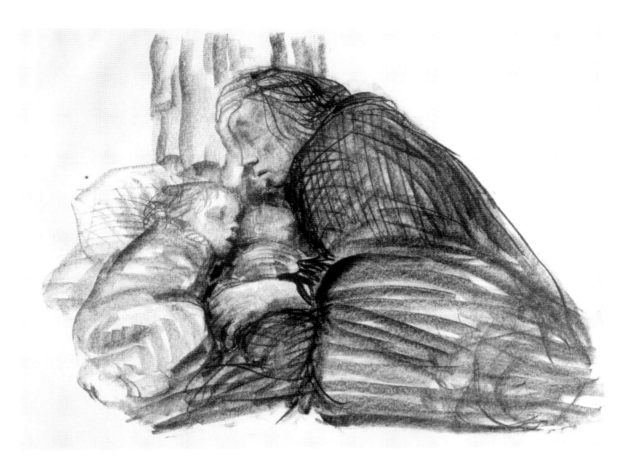

65

Municipal Shelter
1926
Transfer lithograph on laid paper
48.3 x 66.0 cm (irregular sheet)
Art Gallery of Ontario, gift of W. Gunther
and Elizabeth S. Plaut, 1995

64

Municipal Shelter
1926
Charcoal on laid paper
60.0 x 45.0 cm
Graphische Sammlung,
Staatsgalerie Stuttgart

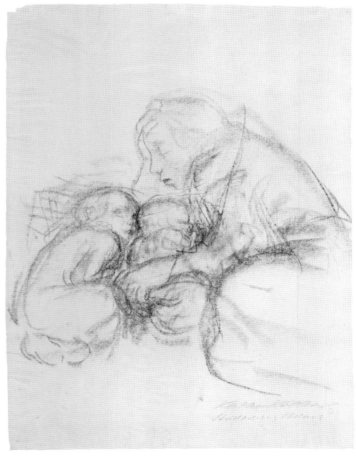

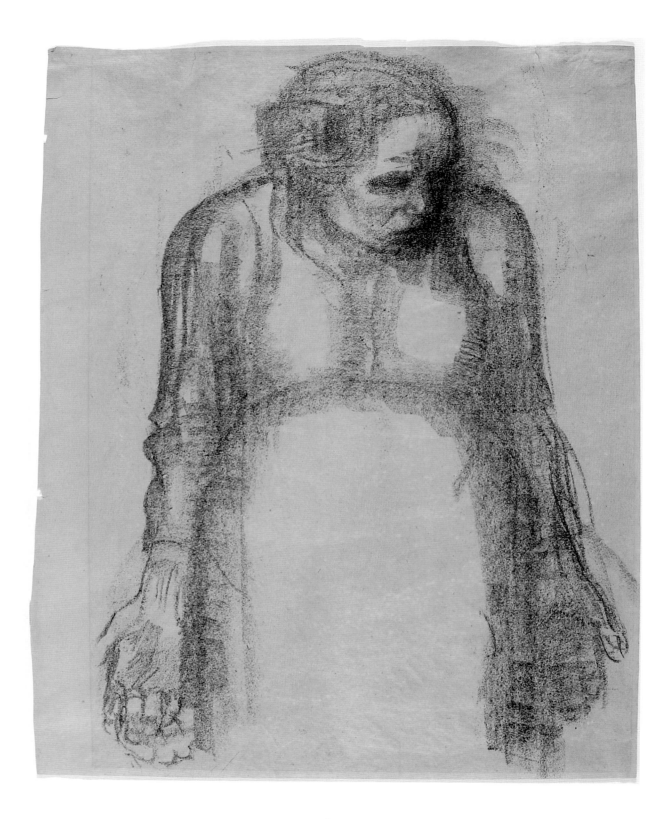

54

The Widow I

1920

Lithograph on wove paper

45.3 x 36.0 cm (irregular sheet)

Art Gallery of Ontario, gift from the

collection of Rose and Louis Melzack, 1989

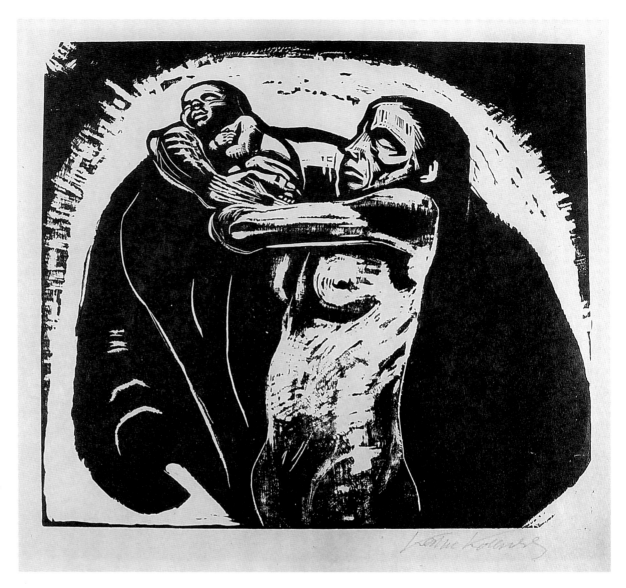

55

The Sacrifice
1922
Sheet 1 from *War*
Woodcut on brown wove paper
37.0 x 40.0 cm (image)
Art Gallery of Ontario,
gift from the collection of
Rose and Louis Melzack, 1989

Similarly, when Kollwitz created her major indictment against war and all its terrors in the *War* portfolio (cat. nos. 53–57) of 1922–23, she again chose the woodcut process. Each image symbolized some aspect of the harsh reality of war from the point of view of those who stayed at home. As with Kollwitz's consistent preference for depicting victims instead of oppressors, she chose the situation that related to her own experience most directly. *The Volunteers* (cat. no. 53, illus. p. 64) shows a skeleton beating a drum and leading four young volunteers in a macabre dance. In *The Sacrifice* (cat. no. 55), a nude woman blindly offers up her baby, and in *The People* (cat. no. 57), a crowd of mockers swarms around a mask-faced woman and her terrified child.

When Adolph Hitler and the National Socialist Party came to power in 1933, it was no surprise that much of Kollwitz's work was deemed unpatriotic. She quickly lost her position and her studio at the Berlin Academy of Art and she was forbidden to publish or exhibit her work. Ironically, some of her designs were appropriated by the Nazis to promote their own propaganda. In 1943 she was forced to evacuate to Nordhausen, and later the same year many of her printing plates and works of art were destroyed when her house in Berlin was bombed.

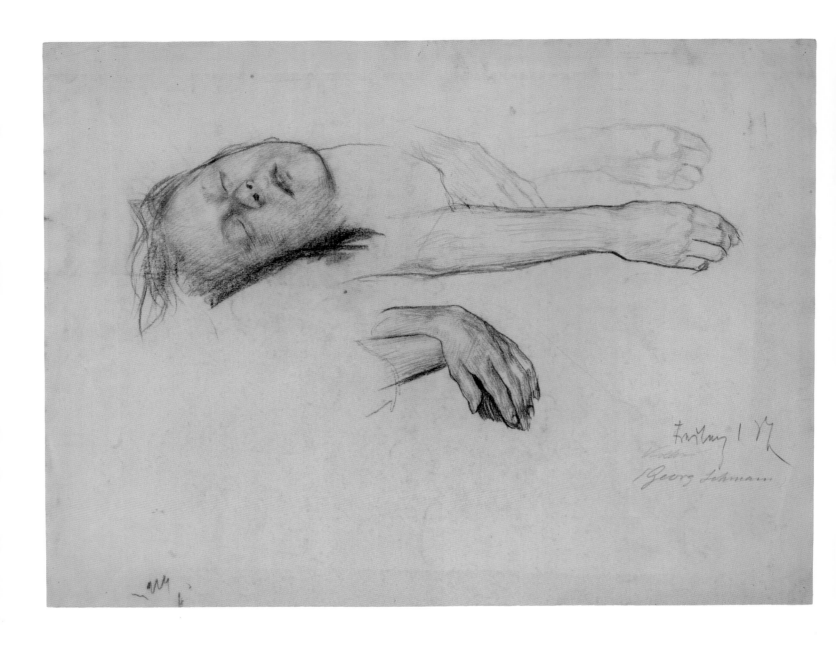

22

Head and Hands of a Sleeping Boy
1903
Charcoal over graphite on wove paper
48.0 x 63.0 cm
Graphische Sammlung, Staatsgalerie Stuttgart

Death

Kollwitz's sister Lise once accused the artist of having a lifelong "dialogue with Death."[36] One could imagine Kollwitz replying, as she did when asked why she focused on suffering, that death was part of life and her subject was "life itself."[37] Themes such as loss and separation as they relate to the death of a mother, and particularly to the death of a child, are prevalent in her work and are usually linked in Kollwitz literature to the death of her son Peter in World War I.

Eleven years before Peter's death, however, Kollwitz created her most shocking and iconic variation of this theme in *Woman with Dead Child* (cat. nos. 26, 27, illus. pp. 54, 55). It is difficult to imagine what generated such an overwhelmingly powerful emotion in the artist in 1903. As the nude mother clutches the child to her chest, she almost seems to devour him as much as to mourn him, as if she were trying to pull him back into herself.[38] Certainly, in her husband's medical practice, she observed many mothers with dead children, since the infant mortality rate in the 1890s from dysentery alone was one in ten.[39] Recent scholarship has examined the centrality of the concept of sacrifice in nineteenth-century German thought. The image may reflect the unbearable but necessary duty of a mother to give up her own flesh and blood for a greater cause.[40]

Technically complex, the print evolved over several states; soft-ground etching and experiments with lithography over-printing and colour applications were tried. Kollwitz used herself and her seven-year-old son Peter as models for the composition, which developed from a series of drawings and prints from 1903 on the theme of the *Pietà* (cat. no. 22). Several drawings and versions of the print exist, some of which were printed with gold highlights.

Other disturbing and emotionally charged variations on this theme include *Death and Woman* (cat. no. 41, illus. p. 34) of 1910 and *Death Tearing Child from Its Mother* (cat. no. 44, illus. p. 42) of 1911, which also predate Peter's death. One writer has used such works to suggest that Kollwitz equated the maternal state with the artistic one. At a time when the roles of artist and mother were viewed as irreconcilable, the maternal nude was a means for the artist to address issues of sexual and creative identity and acted as a metaphor for the specifically female model of creativity. The recurrent imagery of the dead child may thus point to the fear of loss of her own productivity and identity as an artist. [41]

Death in various guises figured prominently in Kollwitz's work during the last decade of her life. In her lithographed series *Death* (cat. nos. 69–71) of 1934–35, and in many other images, victims are attacked by the figure of a skeleton, who is shown dragging or swooping upon his terrified prey. In this theme not just the victim but also the aggressor is described. Kollwitz here looks to her countryman Hans Holbein and the tradition of the medieval dance of death. In many such images Kollwitz expressed her horror of a young person – child or mother – being stalked and violently attacked by the Grim Reaper. In contrast, at the end of her own long, productive career, she resolved to meet death with dignity. She looked forward to the peace it afforded and in images such as *Call of Death* (cat. no. 71, illus. p. 39) and *Woman Entrusting Herself to Death* (cat. no. 70), the serene face of the dying woman resembles that of Käthe Kollwitz.

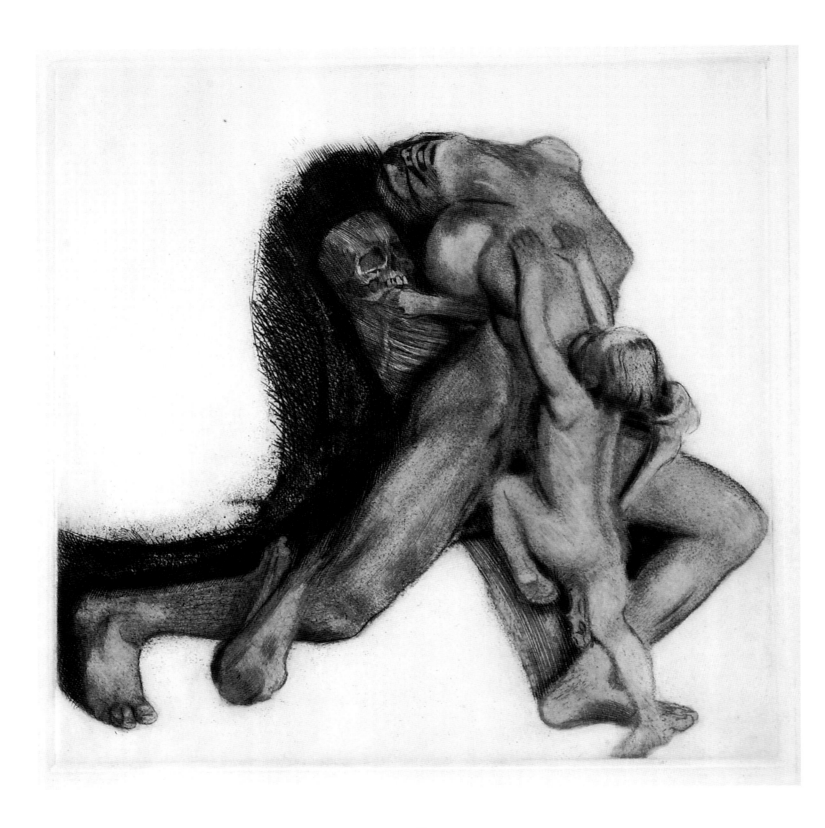

41

Death and Woman
1910
Etching, drypoint, sandpaper, soft-ground
and roulette on wove paper
44.7 x 44.6 cm (imp.)
Collection of Barry Callaghan and Nina Callaghan

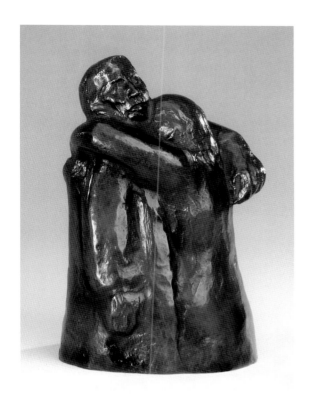

76

Farewell

1940/41

Bronze

17.4 x 11.1 x 11.4 cm

Private collection, Toronto

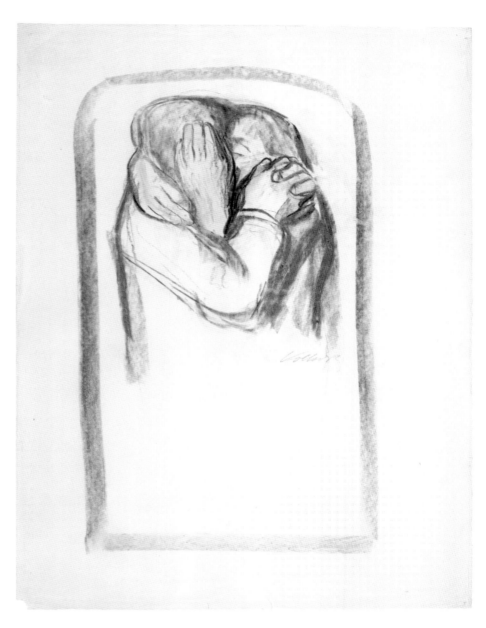

62

Embrace

c. 1924/25

Charcoal on laid paper

64.0 x 48.5 cm

Graphische Sammlung, Staatsgalerie Stuttgart

Sculpture

Kollwitz made approximately twenty-five sculptures. In 1904 she studied sculpture at the Academy Julien in Paris and visited the studio of Auguste Rodin. In 1907 she spent several months in Florence, where she also studied sculpture. Following her return to Berlin the same year, she began to model in clay. Many of her sculptures were either grave reliefs or made as memorials to loved ones. *Farewell* (cat. no. 76, illus. p. 35) represents the grief she felt as her husband slipped away from her in death in 1940. Other works express the peace to be found in death. *Lamentation: In Memory of Ernst Barlach* (cat. no. 75) was a personal tribute to her deceased artist friend, which she modelled after her own face. Similarly, her face appears in the profoundly moving *Resting in the Peace of His Hands* (cat. no. 72, illus. p. 38), a version of which became her own gravestone.

Following the death of Peter in 1914, Kollwitz became preoccupied with making a monument in his memory. This ambitious project was in the works for the next seventeen years, until it was installed in 1931 in the Roggevelde War Cemetery in Belgium. Two enormous stone figures, representing a mother and a father, preside over rows and rows of small wooden crosses. The parents are bent over in grief and bear the facial features of the artist herself and her husband, Karl.

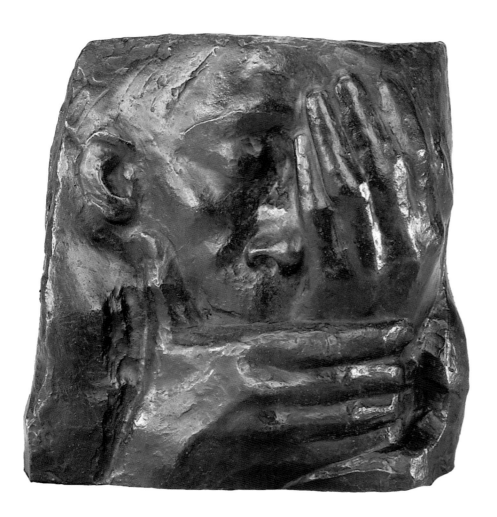

75

Lamentation:
In Memory of Ernst Barlach
1938
Bronze
26.5 x 25.7 x 10.2 cm
Art Gallery of Ontario, gift
from the Junior Women's
Committee Fund, 1963

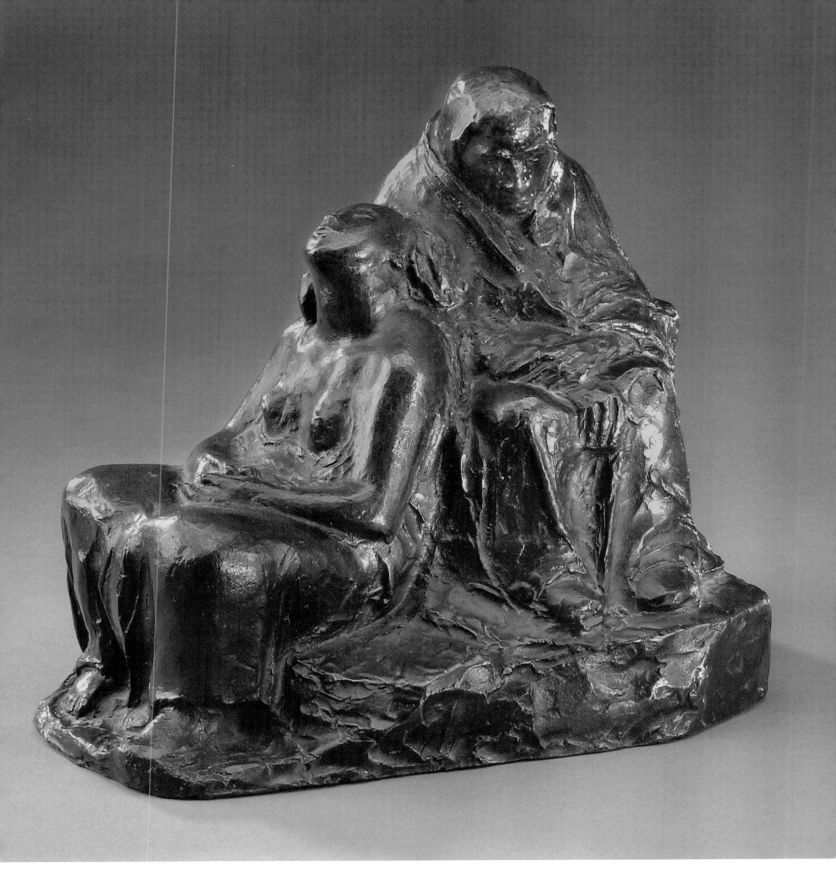

77
Two Waiting Soldiers' Wives
1943
Bronze
22.5 x 25.0 x 20.5 cm
Collection of Dr. Louis Myers

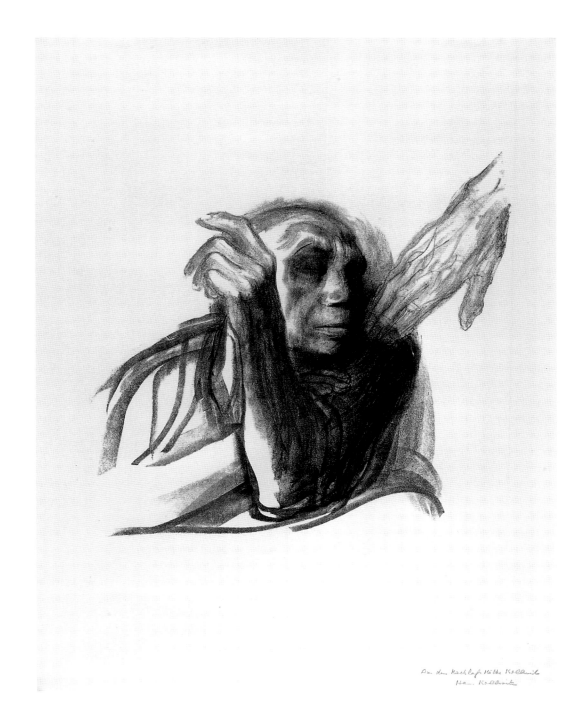

71

Call of Death
1934/35
Sheet 8 from *Death*
Lithograph on wove paper
38.0 x 38.3 cm (comp.)
Collection of Mark and
Judy McLean

Last Days and Legacy

72

*Resting in the Peace
of His Hands*
c. 1935
Terracotta
35.5 x 31.5 x 10.0 cm
Levy Bequest purchase,
McMaster University
Collection, Hamilton

Käthe Kollwitz spent her last days in the care of her granddaughter Jutta, in a small house pro-vided by Prince Ernst Heinrich of Saxony, near the Moritzburg Castle outside Dresden. She died on April 22, 1945, a few weeks before the end of World War II, leaving an enormous legacy both as a woman and as an artist. Over a long career, she shifted the focus of her art away from the narrative, illustrative mode of the early prints and drawings to universalized, simplified presenta-tions inspired by daily life and current issues. She never abandoned her socialist roots and remained committed to chronicling the lives and experience of the working class. Kollwitz's instinctive, heartfelt empathy with the plight of the women around her inspired the creation of an art of great emotional presence and power, an art of true compassion. ■

Endnotes

1 *The Diary and Letters of Kaethe Kollwitz*, ed. Hans Kollwitz. trans. Richard and Clara Winston (1955; Evanston, IL: Northwestern University Press, 1988). Diary entries dated 12 January 1920 and 26 February 1920, 97.

2 *Diary and Letters*, diary entry dated October 1920, 98.

3 *Diary and Letters*, diary entry dated 27 August 1916, 73.

4 *Diary and Letters*, from comments in "In Retrospect 1941," 37.

5 Alexandra von dem Knesebeck, *Käthe Kollwitz: Die prägenden Jahre* (Petersburg: Michael Imhof Verlag, 1998), 38. Knesebeck argues that Kollwitz went to Berlin in 1886, when she was nineteen rather than seventeen, as has been stated elsewhere. This conclusion is problematic since Kollwitz saw Max Klinger's *A Life* series while she was in Berlin, and it was exhibited there in 1884 but not in 1886. See Jay A. Clarke, "The Construction of Artistic Identity in Turn-of-the-Century Berlin: The Prints of Klinger, Kollwitz, and Liebermann," (Ph.D. diss., Brown University, May 1999), 198, footnote 106.

6 Clarke, "Construction of Artistic Identity," 198–99. Clarke points out that it was the early Klinger series of the 1880s that inspired Kollwitz. His prints of this period derived from French Naturalist literature and were his most socially critical. See chapter one of Clarke's dissertation, for a discussion of the importance of printmaking in Germany at the end of the nineteenth century.

7 Max Klinger's influential treatise, *Malerei und Zeichnung*, was published in 1891. Kollwitz had taken up etching and largely abandoned oil painting by that date, but Klinger's writings would have reaffirmed her decision to be a printmaker.

8 A major study of the formal and technical aspects of her art can be found in Elizabeth Prelinger, "Kollwitz Reconsidered," in *Käthe Kollwitz* (Washington, D.C.: National Gallery of Art, 1992). For full descriptions of Kollwitz's techniques, see the new catalogue raisonné by Alexandra von dem Knesebeck, *Käthe Kollwitz: Werkverzeichnis der Graphik* , 2 vols. (Bern: Kornfeld, 2002).

9 *Diary and Letters*, diary entry dated 30 December 1909, 52.

10 Her preoccupation with hands is reflected in the reference to the large, expressive hands of her grandfather and her mother in *Diary and Letters*, "In Retrospect 1941," 29, and from her study of Dürer's drawings of hands, *Diary and Letters*, diary entry dated 24 September 1909, 52.

11 *Diary and Letters*, diary entry dated 9 September 1909, 51.

12 Kollwitz was not the first young artist to find that her own face provided a ready, inexpensive model. Rembrandt, for example, explored a wide range of emotions in his youthful self-portraits. Kollwitz, however, shows an emotion such as laughing in only one self-portrait drawing, dated to 1888/89. Illustrated in Otto Nagel and Werner Timm, *Käthe Kollwitz: Die Handzeichnungen* (Berlin, 1972), catalogue no. 7.

13 See Knesebeck, *Käthe Kollwitz: Die prägenden Jahre*, 95–97.

14 See, for example, Freya Mülhaupt and Dietlinde Hamburger, *Self-Portraits from the 1920s: The Feldberg Collection* (Berlin and Toronto: Berlinische Galerie, Landesmuseum für Moderne Kunst Photographie und Architektur, 2002).

15 It has been suggested that as Kollwitz grows older and undergoes a number of personal tragedies, especially the death of her son, her self-portraits show her as depressed and heavy-hearted, while her last self-portraits are suggestive of her looking toward her impending death. See Jutta Hülsewig-Johnen, ed., *Käthe Kollwitz: Das Bild der Frau* (Bielefeld: Kunsthalle, 1999).

16 Gisela Schirmer, *Käthe Kollwitz und die Kunst ihrer Zeit: Positionen zur Geburtenpolitik* (Weimar:Verlag und Datenbank für Geisteswissenschaft, 1998). Schirmer characterizes Kollwitz's representations of the theme of motherhood as "rebellious" (1890s–1910), "melancholy" (1910–1914), and "ambivalent" (after 1914).

17 *Diary and Letters*, diary entry dated April 1910, 53.

18 Clarke, "Construction of Artistic Identity," 162. Printmaking was not taught at the school until Kollwitz was appointed as instructor in 1898. See also J. Diane Radycki, "The Life of Lady Art Students: Changing Art Education at the Turn of the Century," *Art Journal*, 42 (Spring 1982): 9–13.

19 See Jay A. Clarke, "Neo-Idealism, Expressionism, and the Writing of Art History," in *Negotiating History: German Art and the Past* (Chicago, The Art Institute of Chicago, 2002) vol. 28, no. 1 of the series *Museum Studies* (Spring 2002): 27.

20 *Diary and Letters*, "In Retrospect 1941," 40.

21 Clarke, "Construction of Artistic Identity," 202–04. Clarke discusses the earliest exhibitions of Kollwitz's work; see also the essay by Jay A. Clarke in this catalogue.

22 Jay A. Clarke, review of *Käthe Kollwitz: Die prägenden Jahre*, by Alexandra von dem Knesebeck; *Käthe Kollwitz und die Kunst ihrer Zeit: Positionen zur Geburtenpolitik*, by Gisela Schirmer; *Käthe Kollwitz: Das Bild der Frau*, ed. by Jutta Hülsewig-Johnen, with contributions by Knesebeck and Schirmer; in *Art on Paper* 6 (January-February 2001): 100.

23 *Diary and Letters*, "In Retrospect 1941," 43.

24 Ibid.

25 *Diary and Letters*, "In Retrospect 1941," 42. Kollwitz called the performance "a milestone in my work." See Knesebeck, *Die prägenden Jahre*, 98. The story in the prints follows a narrative sequence, reminiscent of the thematic engraving series of the British artist William Hogarth, which Kollwitz studied and admired in her youth.

26 "At the time I had so little technique that first attempts were failures. For this reason the first plates of the series were lithographs, and only the last three successfully etched." Ibid., 42.

27 See Peter Paret, *The Berlin Secession: Modernism and Its Enemies in Imperial Germany* (Cambridge, Mass. and London: Harvard University Press, 1980), 21. The minister of culture told the kaiser that the "subject of the work and its naturalistic execution [is] entirely lacking in mitigating or conciliatory elements."

28 Prelinger, *Käthe Kollwitz*, 25–26. Prelinger notes that the preliminary drawing shows the woman with arms folded but the print with arms at her sides and fists clenched.

29 Knesebeck , *Die prägenden Jahre*, 206–08.

30 Wilhelm Zimmerman's *Allgemeine Geschichte des grossen Bauernkrieges* [General History of the Great Peasants' War] was published in 1841–42.

31 Prelinger, *Käthe Kollwitz*, 31–39.

32 Linda Nochlin, *Representing Women* (London: Thames and Hudson, 1999), 99.

33 Kollwitz told Otto Nagel that she identified with Black Anna. Otto Nagel, *Käthe Kollwitz* (Greenwich, Conn., New York Graphic Society, 1971), 35.

34 Käthe Kollwitz, *Die Tagebücher*, ed. Jutta Bohnke-Kollwitz (Berlin: Siedler, 1989), October 1920, 483, cited in Prelinger, *Käthe Kollwitz*, 80.

35 See Amy Namowitz Worthen, "Käthe Kollwitz," in *Three Berlin Artists of the Weimar Era: Hannah Höch, Käthe Kollwitz, Jeanne Mammen*, ed. Louise Noun (Des Moines, Iowa: Des Moines Art Center, 1994), 52–91.

36 Kollwitz to her sister Lise, *Diary and Letters*, letter dated February 1945, 195.

37 Kollwitz to her son Hans, *Diary and Letters*, letter dated May 1917, 157.

38 Kollwitz was aware of Edvard Munch's *The Vampire*, a shocking portrayal of two lovers painted in 1893 and reworked in prints from 1895 to 1902. See Prelinger, *Käthe Kollwitz*, 39–40.

39 Gisela Schirmer, in *Käthe Kollwitz: Das Bild der Frau*, 112. She also cites a study by S. Tönnies that refers to Kollwitz's mother and the death of three babies, one of whom died when Kollwitz was a young girl. Tönnies argues that these prints of mothers with dead babies reflect the unresolved trauma of Kollwitz's mother and that the artist had a pathological longing for death.

40 For a discussion about sacrifice, see Gisela Schirmer, in *Käthe Kollwitz: Das Bild der Frau*, 111; Elizabeth Prelinger, "Sacrifice and Protection: The Double-Sided Coin in Kollwitz's Life and Art," in *Käthe Kollwitz: Schmerz und Schuld. Eine motivgeschichtliche Betrachtung* (Berlin: Käthe Kollwitz Museum, 1995), 66–74; and Angela Moorjani, "Sacrifice, Mourning and Reparation: Käthe Kollwitz" in *The Aesthetics of Loss and Lessness* (New York: St. Martin's Press, 1992).

41 Rosemary Betterton, *An Intimate Distance: Women, Artists and the Body* (London and New York: Routledge, 1996), 41–45. Kollwitz links her artworks and her children in a letter to her son Hans, "As you, the children of my body, have been my tasks, so too are my other works," in *Diary and Letters*, diary entry dated 21 February 1915, 146.

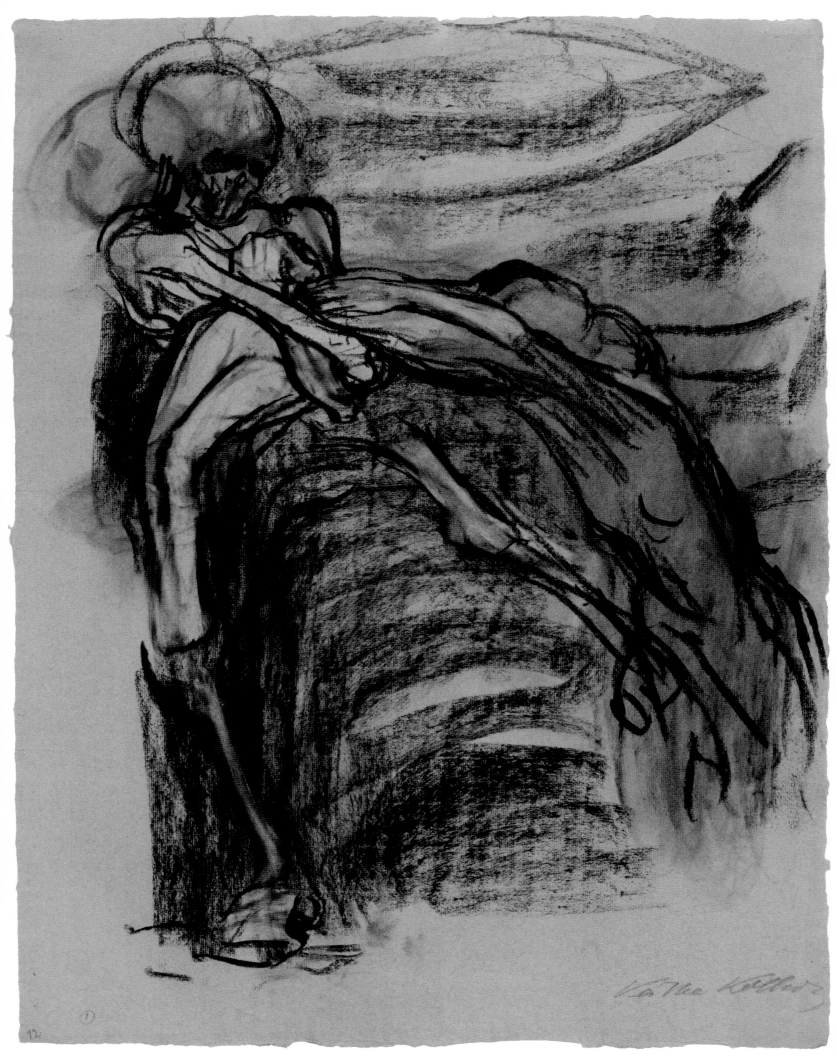

Käthe Kollwitz

Beyond Biography

Käthe Kollwitz and the Critics

BY JAY A. CLARKE THE ART INSTITUTE OF CHICAGO

black chalk and charcoal on grey laid paper, 63.0 x 47.9 cm
Graphische Sammlung, Staatsgalerie Stuttgart

OVER THE PAST HALF CENTURY, OUR PERCEPTION of Käthe Kollwitz's prints and drawings has been inextricably bound to her biography as if to "explain" her life is to "explain" her art. Biography is commonly deployed, for example, to enrich our understanding of drawings like *Death Tearing a Child from Its Mother* (cat. no. 44). The emotive sensibility of such works has been connected to the death of her son Peter during World War I. While her work was undoubtedly affected by this tragic loss, it is, however, problematic to tie this event to works created several years prior. As Brenda Rix's essay explores, there are clear connections between Kollwitz's art and her biography. There is no question that the artist was inspired by her own political, social and personal circumstances to create an art of social difference.

Enlightening as these connections are, biography only tells part of the story. This essay will turn down the volume, so to speak, on Kollwitz's own voice as it is presented in her diaries and letters and will instead turn up the volume on the critics, curators and art historians who wrote about Kollwitz during her lifetime. By reframing the artist in a critical context rather than a biographical one, we gain access to contemporary beliefs and interpretations (be they right or wrong) of her work, ones that did not deploy biography but rather viewed her prints and drawings through the shifting lenses of gender and politics. Critics writing on the occasion of Kollwitz's second public exhibition in 1893 denounced her work as overly masculine and degenerate, whereas by the end of the First World War in 1918 cultural commentators described the very same images as visions of maternal empathy and strength. We will explore how and why this radical shift took place in the gendering of her work and how her prints and drawings took on a variety of fluctuating ideological meanings during this period.

The critical reception of Kollwitz's work up until the end of World War I was intricately linked to the perceived social "dilemma" of the woman artist. The heated debate surrounding women's entrance into the German art world was discussed in both scholarly journals and the popular

43

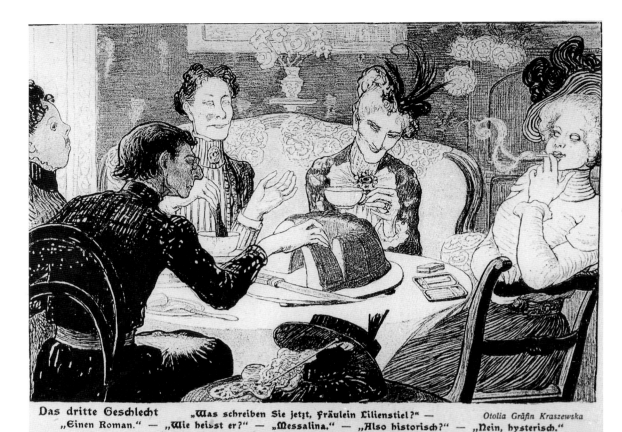

Das dritte Geschlecht „Was schreiben Sie jetzt, Fräulein Lilienstiel?“ — Otolia Gräfin Kraszewska
„Einen Roman.“ — „Wie heisst er?“ — „Messalina.“ — „Also historisch?“ — „Nein, hysterisch.“

Figure 1

Otolia Gräfin Kraszewska, *The Third Sex*, in *Jugend*, 31, 1900, 525. Courtesy of the Ryerson and Burnham Libraries, The Art Institute of Chicago

press. In 1900 the Polish artist Countess Otolia Kraszewska created a caricature for the German satirical journal *Jugend* that speaks to this debate. Entitled *The Third Sex* (fig. 1), the image depicts a group of modern, creative women seated around a table. One of the women asks, "What are you currently writing, Miss Lilienstiel?" to which another replies, "A novel." "What is it called?" – "Messalina" – "Historical, then?" – "No, hysterical."[1] Three of the women represented are overly masculine in demeanour with unattractively mannish faces and thin, desexualized bodies. A fourth woman, overtly sensual and voluptuous, at which a threatening knife is pointed, sits smoking a cigarette, then perceived as an act of defiance and immorality, while a fifth looks on with a blank stare. The term from which the caricature's title derives, *The Third Sex*, comes from turn-of-the-century scientific parlance, which described women whose appearance was explicitly masculine. It also denoted lesbians, feminists and creative women whose "hysterical" thoughts and emancipated careers lured them away from home and hearth. This type of woman was also referred to as *Mannweib*, or "man-woman." As we will see, Kollwitz herself occupied the controversial and uneasy terrain of the woman artist. Although critics did not overtly proclaim her a member of the third sex or a man-woman, largely because she was a wife and a mother, they nonetheless critically positioned her somewhere in between the feminine and masculine realms, thereby implicating her within this conflicted social context.

Kollwitz's first public exhibition in her native Berlin was at the enormous, annual Great Berlin Art Exhibition of 1893, organized by the Berlin Academy, where she exhibited two prints. This well-respected venue held annual exhibitions to showcase government-supported and trained artists and occasionally allowed nonmembers such as Kollwitz to submit work on a juried basis. Not surprisingly, given Kollwitz's unknown status and the 2,103 other paintings, sculptures and prints with which she competed for attention, her entries did not merit a word in the popular press. Yet at her second public outing, an unusual venue called the Free Berlin Art Exhibition,

the artist's three entries — two drawings and one print — were deemed worthy of commentary. Organized as a protest against the exclusiveness of the Academy, the Free Berlin Art Exhibition signalled the emergence of a vanguard that sought to combat their monopoly of yearly academic shows. Before the 1890s, the Berlin art community, controlled by the conservative, state-regulated and funded Berlin Academy, had seen very little progressive art.[2] Among Kollwitz's co-exhibitors at this new venture were Max Liebermann and Edvard Munch, two artists who had come to epitomize the introduction of international trends into German art, namely, Impressionism and Symbolism.

The majority of reviews for this newsworthy exhibition eschewed discussion of specific works and concentrated instead on the radical formation of the show itself. But Ludwig Pietsch, doyen of the Berlin art critics whose conservatism reflected that of the Berlin art establishment, did discuss Kollwitz's work. He singled out her drawings and one print as endemic of the exhibition's immorality. At this time art that contained unidealized images of the poor, created in an artistic style associated with French Naturalism or Impressionism, was perceived by figures such as Pietsch to be morally questionable. Following Germany's defeat of France in the Franco-Prussian War of 1870–71, any artistic style or subject matter influenced by French Naturalism or Impressionism was deemed anti-German. Quoting Goethe's play *Faust, Part 1* (1808) to berate Kollwitz's art and her sex, Pietsch rhymed: "When the road leads to an evil place, woman has a head start in the race."[3] For him, Kollwitz's socially critical images revealed the degradation of both Berlin's alternative art community and women's art production. Pietsch's vocabulary and theoretical approach was indebted to the popular, if conflicted, national-liberal German physician Max Nordau, whose book *Degeneration* (1892) had become influential to a generation of scholars. Pietsch's beliefs in many ways embodied a larger preoccupation of the period that linked feminization and French style with cultural degeneration.

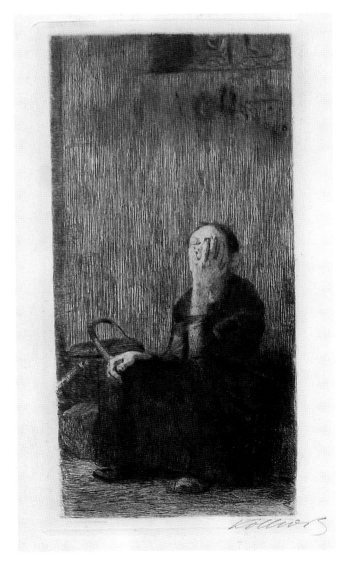

It is no coincidence that Pietsch invoked the misogynist couplet from Goethe's *Faust*. One of the works shown, *At the Church Wall*, 1893 (cat. no. 6), represents a modernized scene from the play, when Gretchen realizes she is pregnant by Faust. Covering her face in dismay, she seeks consolation at the shrine of the Virgin, located on a city street in a niche above her head. Kollwitz presents Gretchen in a decidedly unelevated pose and setting and etches the scene in open, scratchy lines, thereby transforming Goethe's tale — then viewed as the epitome of German Romantic literature — into one revealing the woman's poverty and desperation.

6
At the Church Wall
1893
Etching and drypoint on wove paper
24.9 x 13.2 cm (imp.)
Private collection, Toronto

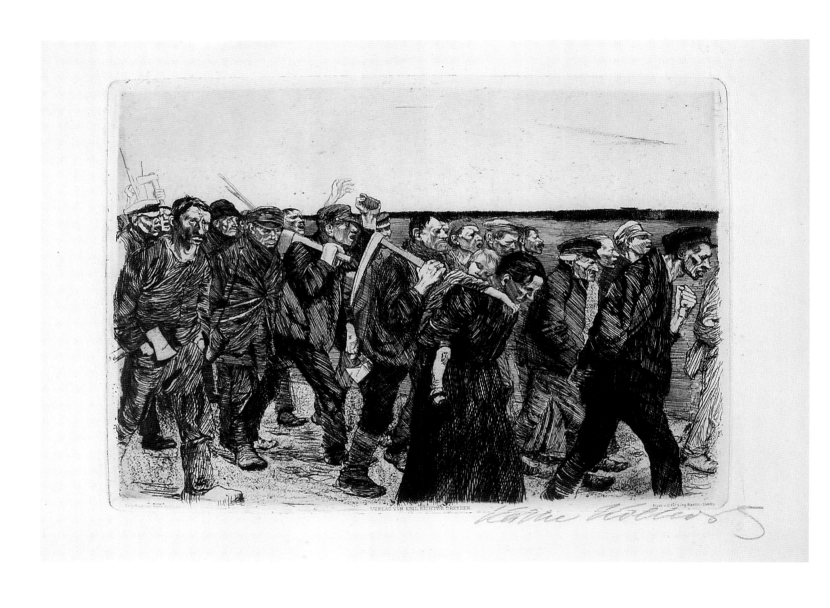

9

The Weavers' March
1897
Plate 4 from *A Weavers' Rebellion*
Etching and sandpaper on cream wove paper
21.1 x 29.2 cm (imp.)
Collection of Ramsay and Eleanor Cook

To understand just how unusual Kollwitz's images must have seemed to her contemporaries, it is important to consider the restrictions placed on women artists during this period. The battles fought by feminists during the 1880s and 1890s to provide women with education and accredited qualifications, allowing them to enter the workforce, were met with limited success. Because women were banned from the state-run art academies, their only options for training were to enter overcrowded women's art academies or prohibitively expensive private ateliers run by male artists.[4] Choosing a career as an independent professional artist was not a respectable vocation for a woman.

Yet, despite these restrictions, by the mid-1890s women artists' exhibitions were regularly reviewed in the popular press. These separate but by no means equal venues included the annual exhibitions of the Berlin Women's Art Union and a handful of forward-looking Berlin art dealers.[5] Progressive critics denounced the works as produced by "uninteresting dilettantes" and their conservative counterparts were even more disparaging.[6] Writing about such shows in 1894 and 1895, Hans Rosenhagen and Johann Rodberg penned scathingly derogatory commentaries. Rosenhagen, editor of the Berlin journal *Das Atelier* and a champion of the emerging Berlin vanguard wrote: "Absent from women's art production is powerful expression, originality of invention, and depth of feeling. The delicate feet of women artists have always walked in the footsteps of men, they have never led, rather they have always followed."[7] Rosenhagen's words were echoed time and again, and the belief that women were best suited to slavish imitation rather than independent invention became a leitmotif in the period criticism. Those that dared to use their gifts of invention, like Kollwitz, were branded either overly "masculine" or morally "degenerate," a

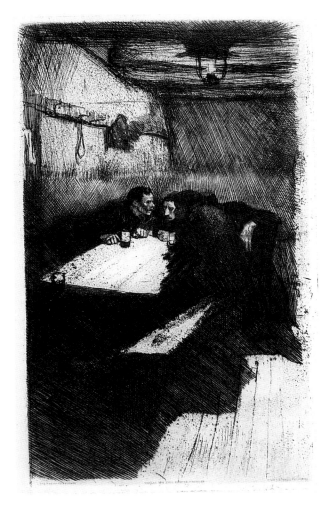

term that came into common use in the 1890s. As we saw in our discussion of Kraszewska's *Jugend* caricature, the creative woman was often viewed as a member of the third sex and described as a man-woman. Rodberg wrote a year later in *Das Atelier* of his fears that they were living in a "time of decadence," where women wore pants, strove for doctorates, and abandoned their rightful position as mothers by longing to become men. Particularly blatant in this social contagion was the women artist, who, if she wished to become successful, lost her feminine characteristics and, as Rodberg suggested, infected society with her unnatural sickness and abnormal tendencies.[8]

The most celebrated rejection of Kollwitz's career was that surrounding the exhibition of her 1898 cycle *A Weavers' Rebellion*, based on the play *The Weavers* (1893) by Gerhart Hauptmann. Kollwitz attended the Berlin debut of this play at the controversial, private theatre Freie Bühne in February of 1893. Over the course of five years, she created a series of six prints – three lithographs and three etchings – *Poverty, Death, Conspiracy* (cat. no. 8), *The Weavers' March* (cat. no. 9), *Storming the Gate*, (cat. no. 10)

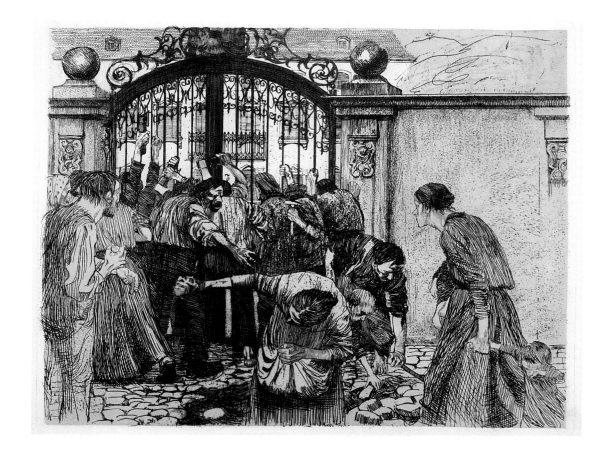

and *End* (cat. no. 11, illus. p. 24). The cycle tells the plight of a group of Silesian linen weavers who, in 1844, revolted against low wages and atrocious living conditions, a narrative that clearly echoed contemporary industrial working conditions in 1890s Berlin. The story begins with the lithograph *Poverty*, in which the mother of a poor weaver's family mourns over her dying child, and then moves on to the weavers' organized conspiracy to avenge their oppressors in *Conspiracy*, illustrated here by an earlier, etched version of the plate. The fate of the men huddled around the table is foreshadowed by the nooselike rope that hangs on the tavern wall above them. Following their scheming, the poverty-stricken men, women and children begin their march on the factory owner's house armed with scythes and axes. This leads to a failed assault upon the factory owner's house in *Storming the Gate* and concludes with the print *End*, in which the dead bodies of the weavers are brought back home.[9]

The print portfolio was exhibited in 1898 at the Great Berlin Art Exhibition, the second time Kollwitz had shown at this esteemed venue.[10] The jury of this Academy-run exhibition voted for Kollwitz to receive a gold medal for the series, a tremendous honour. The Minister of Culture Robert Bosse received the list of proposed medal recipients and promptly wrote to Emperor Wilhelm II: "The suggested prize for the etcher Käthe Kollwitz gives me cause for concern....In view of the subject of the work and its naturalistic execution, entirely lacking in mitigating or conciliatory elements, I do not believe I can recommend it for explicit recognition by the state."[11] Emperor Wilhelm II, who held ultimate veto power for these prizes, likewise rejected the medal, responding in a letter to the Ministry of Culture: "I ask you gentlemen, a medal for a woman, that would be going too far. That would practically amount to a debasement of every elevated distinction. Distinctions and medals belong on the breasts of deserving men."[12]

The reason for this rejection was thus three-pronged. Firstly, the subject of the work was not "conciliatory" enough. Images of the revolutionary proletariat were far too openly confrontational for the repressive government to endorse. Secondly, the "naturalistic execution," namely, the

openly drawn lines of the prints, evoked French Naturalism, a style then associated with Socialism and viewed as politically subversive. Thirdly, Kollwitz was a woman. In Wilhelm II's opinion, the award of this medal to her would belittle the distinction itself and should be saved for "the breasts of deserving men." Yet we know that the emperor did occasionally award medals to women artists – for example, the more conservative printmakers Cornelia Paczka-Wagner in 1890 and Doris Raab in 1892 – and therefore his specific disdain for Kollwitz is revealed.[13] The following year, Kollwitz was vindicated when she won the gold medal for the *Weavers'* cycle at the Dresden Art Exhibition, a more liberal venue. Perhaps capitalizing on her increased notoriety, she continued to display the series at several venues throughout 1899.[14]

As a sign of how quickly Kollwitz's reputation had grown just ten years after her first public exhibition, in 1903 the first catalogue raisonné of her prints was published in the influential, deluxe art journal *Die graphischen Künste*, written by the respected Dresden print curator Max Lehrs.[15] Lehrs's high praise for her prints and drawings in the article was not joined by sexual parity, however. He began by reflecting on the visitors' experience in front of Kollwitz's *Weavers'* portfolio at the 1898 Berlin exhibition. He reminisced:

The effect of these instantly admired sheets, with their free and energetic handling of the etching needle, was all the more amazing when one learned that they came from the hand of a woman. Not just the subject matter, but the masculine power of the delineation, the boldness of the painterly handling contradicted what people had hitherto known about the visual arts from the hand of a woman, as if one stood before a puzzle.[16]

The notion that Kollwitz had overcome the perceived limitations of her gender – that her art was so good, it could have been made by a man – was a recurring motif in the early art criticism on her work. While this is not entirely surprising in an age when women artists were given little respect, barred from state-run art academies and forbidden to vote, it is significant that Lehrs singled out the technical aspects of her work as puzzling. The "free and energetic handling," their "masculine power" and "boldness" of delineation strayed from the prescribed boundaries of academic art and gender. According to social propriety, women artists' drawings were imitative, charming, colourful and, above all, not imaginative. Therefore, Kollwitz's "free" handling of the etching needle was considered equally as inappropriate as her decidedly unfeminine representation of women wielding scythes and heaving rocks.[17]

The question of masculinity in Kollwitz's work continued to elicit both positive and negative responses. Anton Hirsch in his book *Women Artists of Today* (1905) described Kollwitz as the most talented contemporary woman printmaker in Germany, stating she was "one of those artists to whose talents one tends to apply the term 'masculine.' Insofar as this word is identical with deep and powerful, then we will also accept it."[18] Hirsch turned this normally negative characterization around to suggest the artist's strength. Three years later, the influential Berlin printmaker Hermann Struck asserted in his widely read handbook *The Art of Etching*: "[Kollwitz's] motifs are mostly accusations against capitalist society, and many of her sheets resound with the dull cry of the proletariat. Nothing 'feminine' speaks from these sheets. They flash with power and are masculine, sometimes all too masculine."[19] Indeed, for Struck and others, Kollwitz's politically engaged subject matter rendered her masculine. Because her works were repeatedly described as "masculine," Kollwitz's promoters strove to find ways to present her as more feminine.

Anna Plehn, a rare woman art critic, took a new approach to Kollwitz's imagery in an article published in the bourgeois feminist journal *Die Frau* in 1904, one that continued to gain currency in the period criticism. Instead of framing Kollwitz as a woman in a man's world as had others, Plehn drew out what she perceived as the distinctly "female" characteristics in her work. The article focused on Kollwitz's next major series, the *Peasants' War* – a portfolio of seven sheets completed in 1908. The series was a modern interpretation of the German Peasants' War

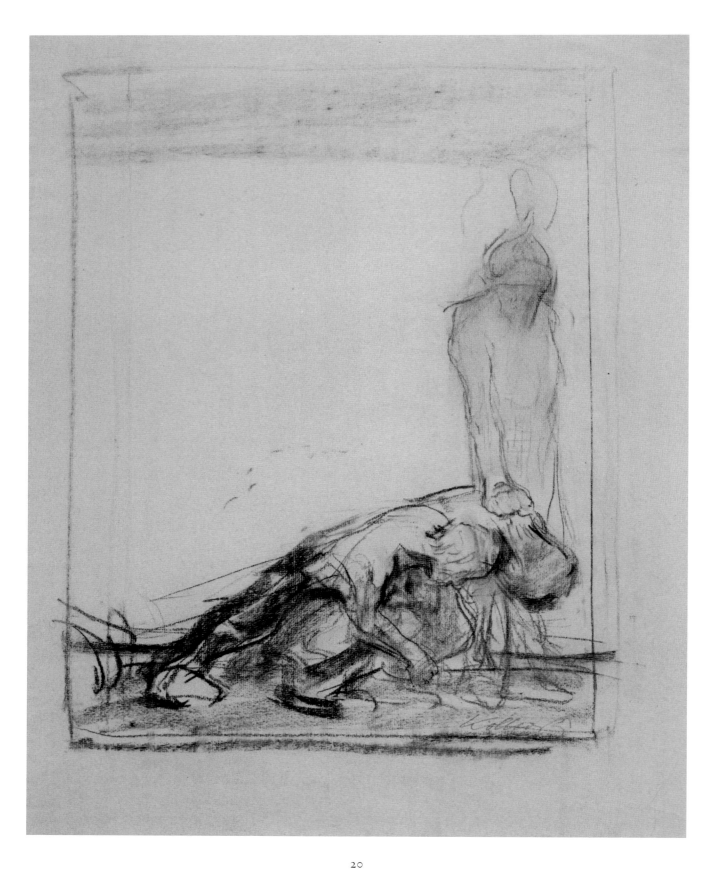

20

Pulling the Plough
c. 1902
Charcoal on grey laid paper
61.5 x 47.5 cm
Graphische Sammlung, Staatsgalerie Stuttgart

(1522–25), which took place during the Reformation, precipitated by the intolerable conditions under which the peasants laboured.[20] The portfolio begins with *The Plowers* (cat. no. 34), a desperate image in which men too poor to own a horse pull the plow themselves. The implication that these indentured labourers were treated as animals is made explicit by their master's oppressive gesture in a preparatory drawing for this print (cat. no. 20). The episodic narrative then moves to the haunting scene *Raped* (cat. no. 37, illus. p. 53), where a peasant woman lays violated in a patch of flowers. In *Sharpening the Scythe* (cat. no. 33, illus. p. 52), a woman prepares for the battle later incited in the dramatic sheet *Outbreak* (cat. no. 24, illus. p. 27). The tale draws to a conclusion with the scene of carnage in *Battlefield* (cat. no. 36) and ends with the peasants' defeat and incarceration in *Prisoners* (cat. no. 39, illus. p. 27). As with the *Weavers'* cycle, this series pointedly echoed the abhorrent condition of industrial labourers in Germany around 1900.

Plehn describes in detail the sheet *Battlefield* (cat. no. 36), in which a woman she identifies as the historical figure Black Anna comes at night with a lantern and sifts through a pile of dead bodies to locate her son. Plehn claims this scene embodied the portfolio's underlying message: not the power of war nor the degraded position of the workers but the sacrifice of motherhood: "It signifies the embodiment of motherly sorrow itself...as the mother must be all alone with the corpse."[21] It was this expression of intense sorrow that Plehn went on to connect with many of Kollwitz's works, particularly the riveting *Woman with Dead Child* (illus. pp. 54, 55).[22] Seen here in the preparatory drawing (cat. no. 26) and the final print (cat. no. 27), a desperate, nude mother sits clutching her dead son. Plehn recalled that Kollwitz, while she created this scene of lamentation, had spoken often of Michelangelo's *Pietà* sculpture (1497–1500, St. Peter's, Rome). And yet the critic contended Kollwitz's conception was far more arresting than her famous Italian Renaissance predecessor's, because the dead child came from her "own flesh and blood." Plehn maintained that a woman artist was best able to envision "what a man's imagination could never see, what a man could probably never feel and what only a woman who is a mother...can depict

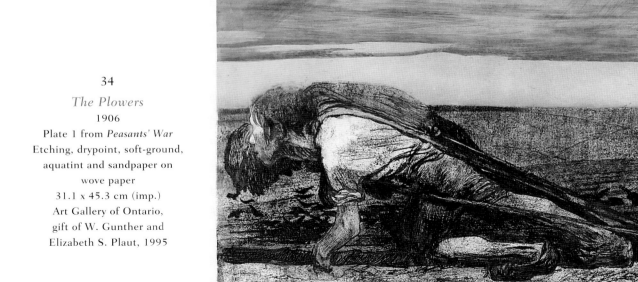

34

The Plowers
1906
Plate 1 from *Peasants' War*
Etching, drypoint, soft-ground, aquatint and sandpaper on wove paper
31.1 x 45.3 cm (imp.)
Art Gallery of Ontario, gift of W. Gunther and Elizabeth S. Plaut, 1995

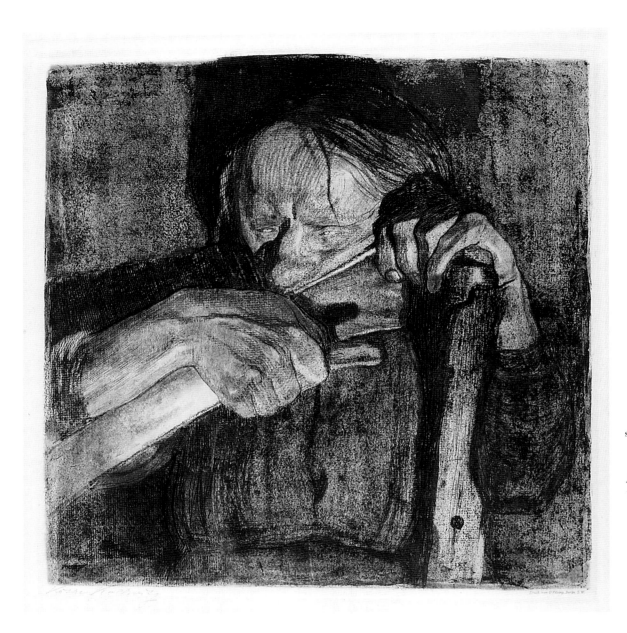

33

Sharpening the Scythe
1905
Plate 3 from *Peasants' War*
Etching, drypoint, aquatint,
sandpaper and soft-ground on
wove paper
29.4 x 29.4 cm (imp.)
Art Gallery of Ontario, gift of
W. Gunther and Elizabeth S.
Plaut, 1995

with such vividness."[23] It is precisely this emotive representation of motherhood that Plehn described as Kollwitz's singular vision. Plehn built her argument by downplaying the violent tone of works like *The Carmagnole* (cat. no. 19, illus. p. 25)) and *Outbreak* (cat. no. 24, illus. p. 27). In this way she reflected the mirror opposite of her misogynist contemporaries by focusing primarily on the "feminine" undertones and glossing over those others had defined as "masculine."

Following the *Peasants' War* series Kollwitz changed her focus from historical narrative to contemporary events. From 1908 to 1911 she produced a series of drawings entitled *Portraits of Misery* for the journal *Simplicissimus,* in which she chronicled the horrors destitute people faced in their daily lives: alcoholism, physical abuse, starvation and unwanted pregnancy. At the same time she created these haunting works, Kollwitz joined the League for the Protection of Mothers, a feminist group that advocated mothers' rights,[24] and soon thereafter founded the Frauenkunstverband, an advocacy group for women artists that encouraged equal opportunity for professional training, exhibition and sales.[25] Not surprisingly, radical feminists such as Lily Braun applauded the example Kollwitz set for other women artists. Her essay "The Female Mind" of 1910 acknowledged women's "pronounced aptitude" for painting and the graphic arts but denounced most contemporary women artists whose subject matter, she felt, typified timidity and

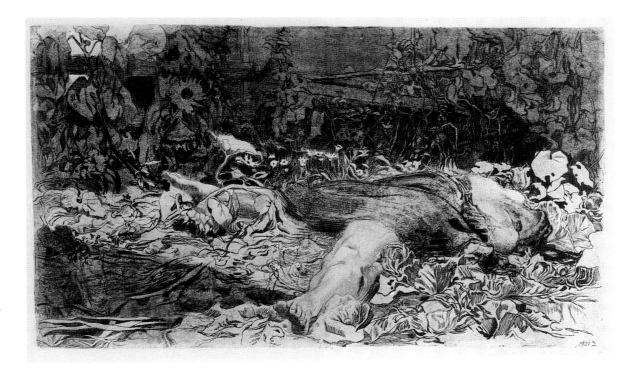

37

Raped
1907
Plate 2 from *Peasants' War*
1907
Etching, drypoint, sandpaper
and soft-ground on laid paper
30.2 x 52.0 cm (imp.)
McMaster University
Collection, Hamilton

lack of individuality. She maintained: "Only a single artist of the present time offers proof that one-sidedness in women's art is not necessarily related to the nature of the female in general: Käthe Kollwitz. Her subject is the life of the people, but not the idyllic one. She leads us into the depths of their squalor and despair."[26] Yet others, such as the historian Karl Scheffler, in his scathingly derogatory book *Women and Art* (1908), claimed that Kollwitz's work "quickly leaves the painful impression that there is a certain line women should never cross."[27] Scheffler believed that women were unable to think abstractly or use their imagination. According to him, their only domain for creativity was in the home, as decorators, or, in Scheffler's own words, as a *Toilettenkünstlerin* (dressing table artist). Thus he felt Kollwitz had crossed over the line of social propriety with her images of political engagement, which were enacted so far from the decorous, feminized dressing table.

In 1911 the twenty-one-year-old writer Max Jungnickel published an article on Kollwitz in the newly founded newspaper *Die Aktion*, which encouraged her political activism. This newspaper, along with its contemporary *Der Sturm*, was one of the most influential publications at this period in German cultural life and strongly promoted the burgeoning Expressionist movement in both art and literature.[28] By the time of Jungnickel's article on Kollwitz, Expressionism was coming into its own and artists such as Ernst Ludwig Kirchner and Karl Schmidt-Rottluff shocked the Berlin art world with their paintings, prints and sculptures of nudes, rendered in bright colours and spatial conceptions that flattened and faceted the picture plane. Kollwitz has long been considered in anthologies and exhibitions on Expressionism as an integral part of this movement with her clearly expressive imagery, but she never exhibited with them and was not necessarily supportive of their artistic program. She felt their work to be overly insular and bourgeois when compared to her more socially oriented imagery. While her subject matter could be considered expressionistic in its employment of emotive and violent imagery, her conventional treatment of space was worlds away from Expressionism's formal concerns.[29] Her "masculinization" derived historically from her iconography, not from the progressive formal qualities of her work. The inclusion of Kollwitz as "one of the boys" in the largely male modernist canon of German Expressionism signifies how the masculine gender stereotypes implicated in her early reception had a lasting impact.[30]

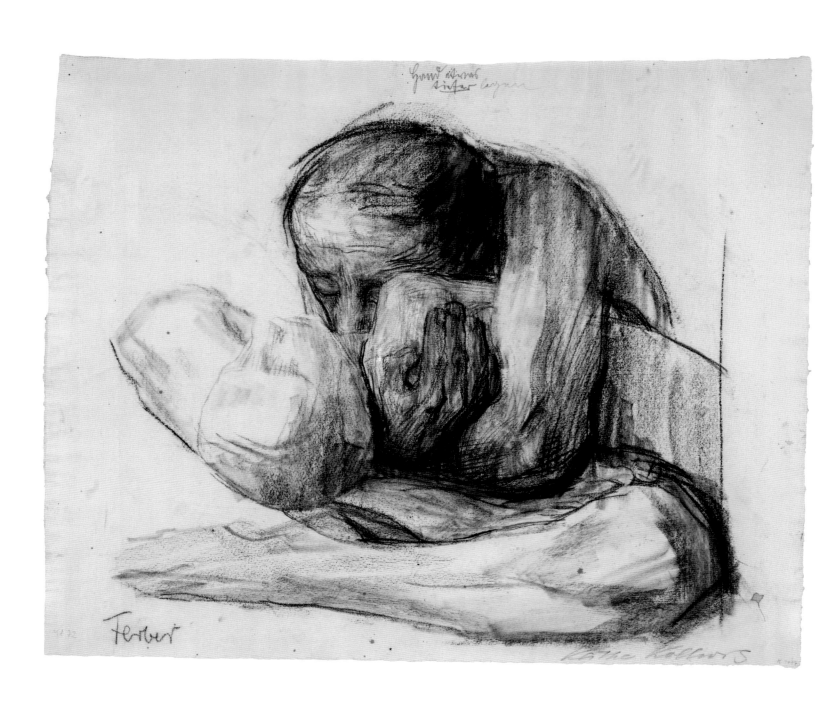

26

Woman with Dead Child
1903
Charcoal over red chalk, heightened
with white on wove paper
46.5 x 56.5 cm
Graphische Sammlung, Staatsgalerie Stuttgart

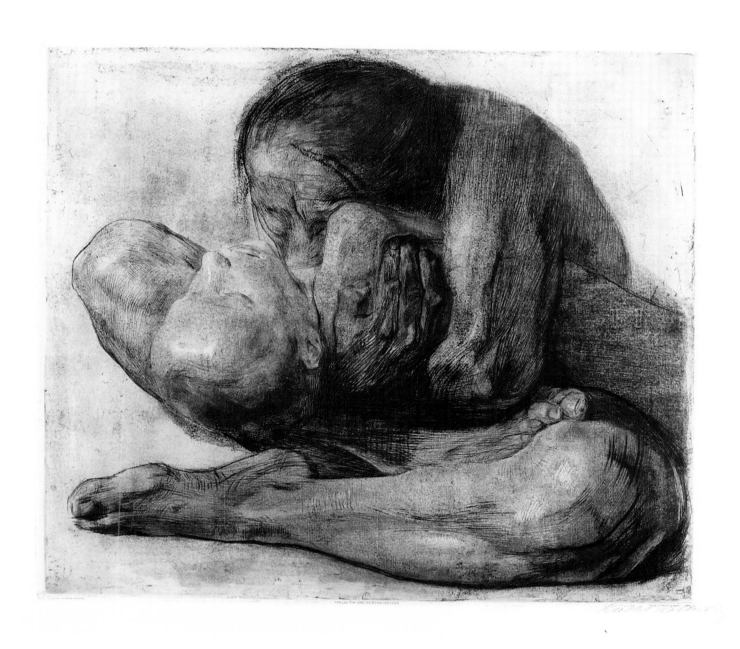

27

Woman with Dead Child
1903
Etching, drypoint, sandpaper and
soft-ground on wove paper
42.1 x 48.2 cm (imp.)
Art Gallery of Ontario, purchase, 1965

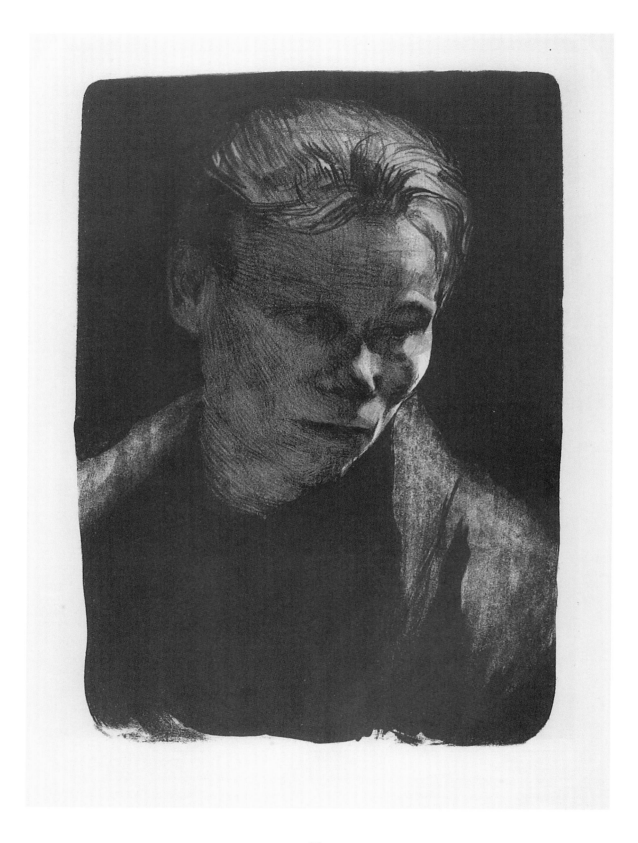

25
Working Woman with Blue Shawl
1903
Colour lithograph on wove paper
35.6 x 24.5 cm (image)
Collection of Ramsay and Eleanor Cook

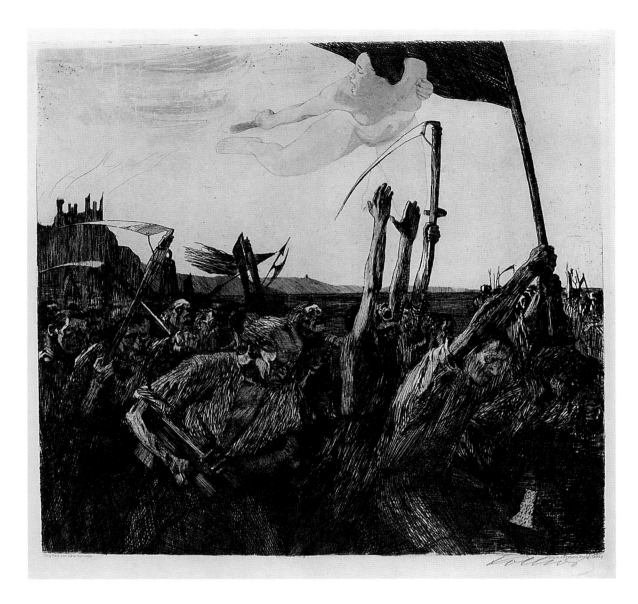

13

Uprising
1899
Etching, drypoint, aquatint,
sandpaper and roulette on
wove paper
29.5 x 31.5 cm (imp.)
Art Gallery of Ontario, gift of
W. Gunther and Elizabeth S.
Plaut, 1995

Jungnickel's article stressed content over form, and he began by introducing Kollwitz as "a woman who, unlike her sisters in Apollo whose azure, golden dreams solicit favour from the public, ...seats the downtrodden and penniless on the throne."[31] Immediately positioning Kollwitz in opposition to other women artists of her day, Jungnickel says, she instead represents the "cry of social need and the blood-curdling scream of the avenging queen."[32] He went on to assert that in her prints the "poor and despairing do not whine and whimper. They lament, cry out for justice."[33] Rightly noting that women held a central position in her work, Jungnickel praised her printed scenes of emotive violence such as *The Carmagnole* (cat. no. 19, illus. p. 25) and *Uprising* (cat. no. 13). Unlike earlier critical commentators whose backhanded praise of her work reinscribed Kollwitz into the gendered roles of Wilhelmine society, Jungnickel applauded her prototypically "masculine" subject matter, describing her work in words of force akin to the Expressionist aesthetic that *Die Aktion* encouraged.

The year 1917 marked Kollwitz's fiftieth birthday, an event that prompted not only several solo exhibitions throughout Germany, but numerous articles in journals and newspapers.[34] Despite the divergent tone of these articles, most shared rhetorically an oppositional strategy that marked a turning point in the Kollwitz reception – one that to a large extent prevails today. This system of binary opposites can be characterized by the dichotomous framing of Kollwitz as, on the one hand, a political agitator and, on the other, an empathetic mother.

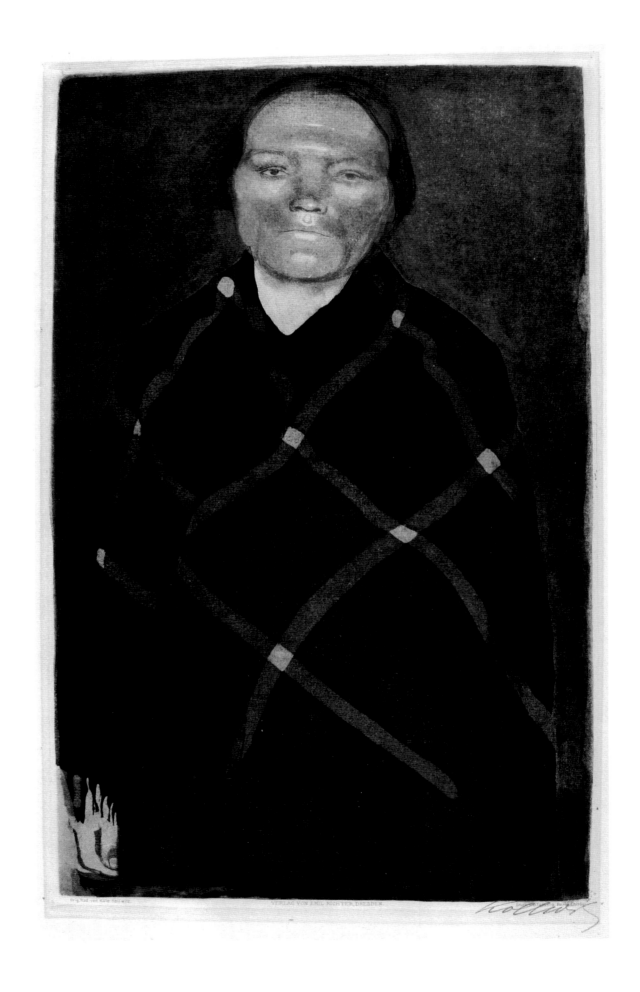

Julius Elias, writing in 1917 for the art journal *Kunst und Künstler*, the literary organ of the Berlin Secession, took a retrospective approach, chronicling the artist's career from 1893 to 1917.[35] Unlike Jungnickel, who described her work as expressionistic and violent, Elias stressed its profound social and idealist message. As he put it: "she accuses in order to free the good in mankind, she strikes wounds in order to heal, she shows the social misery so that happiness may live again on the earth, shows tragedy because she wishes for people to live in paradise.... Kollwitz only appears to be a destructive type, in reality she is a romantic, positive [type]."[36] Elias believed her work predicted social reform and prompted a desire to change society's ingrained traditions of oppression and persecution. Rather than seeing these sheets as negative messages of the downtrodden, he saw them as messages of hope. Hand in hand with this positive message, for Elias, was one of empathy, empathy predicated on gender stereotypes. In addition to her socially critical works, he claimed her maternal images, for example *Pregnant Woman* (cat. no. 42), were "at once real and spiritual, seemingly appearing from the mystical depths of nature, [here] lies the most positive element of her artistic vision."[37] The optimistic message that Elias described as maternal, empathetic and mystical, however, is difficult to reconcile with the predominantly pessimistic tone of the works themselves.

Between 1918, the end of the First World War, and 1933, when the National Socialists took power, this approach continued and critics perpetuated the oppositional devices cemented in the criticism of around 1917. Many of her biographers, from the curators Curt Glaser and Ludwig Kaemmerer to the journalist and writer Louise Diel, penned articles and monographs in the 1920s that reinforced the dualistic presentation of the artist as fighting for democracy, and yet they explained her revolutionary zeal as springing from a feminine, specifically maternal, empathy.[38] When Hitler came to power in 1933 Kollwitz was forced to resign from her professorship at the Berlin Academy. As a result of strict censorship in the press, no articles on Kollwitz appeared in Germany between 1933 and 1944. While German criticism evaporated, interestingly, her cause was taken up in largely anti-German American journals, newspapers and exhibition catalogues, which adopted Kollwitz as a symbol of democracy in the face of oppression. In these publications, she was heralded as an "artist of the people," one who fought for the downtrodden and, echoing the now familiar characterization, was feminine in her feeling for women and children.[39] By 1950 scholars turned to biography as the main mode of explicating her work, perhaps in response to the wide publication and translation of her diaries and letters in the 1950s and 1960s.

The radical shift that took place in Kollwitz's reception reveals the tension that marked women's entrance into the German art world. The male-dominated sphere of art criticism initially denounced Kollwitz's unconventional imagery, describing it as a form of social contagion and characterizing her as a "man-woman." Yet as her reputation grew after the turn of the century, and women's battle for equality gained momentum during the teens, these dissenting voices began to transform into ones of praise. Kollwitz's political engagement in the public sphere had come to embody strength and yet the threateningly shrill tone of her works was tempered and made palatable by emphasizing her maternal role in the private sphere. It is precisely this dichotomy that has allowed Kollwitz to remain an integral component of the predominantly male canon of German modernism. This exceptionally powerful paradox remains in place today and to some extent still drives our perceptions, allowing Kollwitz to be read simultaneously as an empowered socialist-feminist and empathetic mother, and her art interpreted as both radical and reactionary. When we move beyond biography and retrieve the historical context in which her art was created and received, and the restrictive standards by which it was judged, Kollwitz becomes more than an amalgam of biographical facts and dates. She emerges as a socio-cultural phenomenon, a lightening rod for debates about what it meant to be an artist in Germany. ■

42

Pregnant Woman
1910
Etching, drypoint, aquatint and soft-ground on wove paper
37.2 x 23.3 cm (imp.)
Art Gallery of Ontario, gift of W. Gunther and Elizabeth S. Plaut, 1995

Endnotes

My thanks to John F. K. Bradley, Marcia Brennen and David Ehrenpreis for their insightful comments on earlier drafts of this essay and to Catherine van Baren for her careful editing of the manuscript. Carola Kupfer generously provided research assistance and checked over my translations. I am especially grateful to Brenda Rix for inviting me to write this essay, for her thoughtful and informed remarks during the conception and editing of it, and for her inclusiveness throughout the preparation of the catalogue and the exhibition.

1 As translated by Shulamith Behr in "Veiling Venus: Gender and Painterly Abstraction in Early German Modernism," in Caroline Arscott and Katie Scott, eds., *Manifestations of Venus: Art and Sexuality* (Manchester and New York: Manchester University Press, 2000), 130. For more on the term *third sex*, see: Brigitte Burns, "Das dritte Geschlecht von Ernst Wolzogen," in Rudolf Herz and Brigitte Burns, *Hof-Atelier Elvira, 1887–1928: Ästheten, Emanzen, Aristokraten* (München: München Stadtmuseum, 1985), 171–90.

2 For more on the formulation of this group see: Nicolaas Teeuwisse, *Vom Salon zur Secession: Berliner Kunstleben zwischen Tradition und Aufbruch zur Moderne, 1871–1900* (Berlin: Deutscher Verlag für Kunstwissenschaft, 1986), 194–95.

3 As quoted in Martha Kearns, *Käthe Kollwitz: Woman and Artist* (Old Westbury, New York: The Feminist Press, 1976), 68.

4 For more extensive examinations of women's art education in Germany see: J. Diane Radycki, "The Life of Lady Art Students: Changing Art Education at the Turn of the Century," *Art Journal* 42 (Spring 1982): 9–13; Renate Berger, *Malerinnen auf dem Weg ins 20. Jahrhundert: Kunstgeschichte als Sozialgeschichte* (Köln: Dumont, 1982); and Dietmar Fuhrmann and Klaus Jestaedt, "'...alles Das zu erlernen, was für eine erfolgreiche Ausübung ihres Berufes von ihnen gefordert wird...': Die Zeichen und Malschule des Vereins der Berliner Künstlerinnen," in *Profession ohne Tradition: 125 Jahre Verein der Berliner Künstlerinnen*, ed. Berlinische Galerie (Berlin: Kupfergraben, 1992), 356–57.

5 The three most important dealers who promoted women's art in their gallery exhibitions were Amsler and Ruthardt, Fritz Gurlitt and Edouard Schulte.

6 For more on these special exhibitions and their critics, see the author's dissertation: "The Construction of Artistic Identity in Turn-of-the-Century Berlin: The Prints of Klinger, Kollwitz, and Liebermann" (Ph.D. diss., Brown University, May 1999), chapter 2.

7 [Hans] R.[osenhagen], "In Ed. Schulte's Kunstsalon," *Das Atelier* 4 (1984): 4. Unless otherwise noted, all translations are my own.

8 Joh.[ann] Rodberg, "Internationale Ausstellung von Werken berühmter Künstlerinnen," *Das Atelier* 5 (1895): 4. Rodberg's vocabulary and theoretical approach was also indebted to Nordau.

9 For a more complete description of the series see: Alexandra von dem Knesebeck, *Käthe Kollwitz: Die prägenden Jahre* (Petersberg: Michael Imhof Verlag, 1998), 118–73.

10 *Grosse Berliner Kunst-Ausstellung* (Berlin: Schuster, 1898).

11 As quoted in Peter Paret, *The Berlin Secession: Modernism and Its Enemies in Imperial Germany* (Cambridge, Mass. and London: Harvard University Press, 1980), 21.

12 As quoted in Sigrid Achenbach, *Kathe Kollwitz (1867–1945): Zeichnungen und seltene Graphik im Berliner Kupferstichkabinett* (Berlin: Gebr. Mann, 1995), 10.

13 *Grosse Berliner Kunst-Ausstellung, 1893. Verzeichniss der auf den Grossen Kunst-Ausstellungen zu Berlin bin einschliesslich 1892 verliehenen Auszeichnungen* (Berlin, 1893). Stiftung Archiv der Akademie der Künste, Berlin.

14 In 1899 at the Königsberg gallery Hübner and Matz, the Munich Glaspalast exhibition, and the Dresden Kupferstichkabinett.

15 Since 1879 *Die graphischen Künste* had been the most influential journal for the promotion of the graphic arts in Germany and Austria, maintaining an inclusive, if conservative, tenor.

16 Max Lehrs, "Käthe Kollwitz," *Die graphischen Künste* 26 (1903): 56.

17 The history of drawing and printmaking in Germany and its relation to gender is discussed further in Clarke, "Construction of Artistic Identity," chapter 2. Regarding the importance of Kollwitz's technical experimentation, see: Elizabeth Prelinger, "Kollwitz Reconsidered," in *Käthe Kollwitz* (Washington, D.C.: National Gallery of Art, 1992), 13–86.

18 Anton Hirsch, *Die bildenden Künstlerinnen der Neuzeit* (Stuttgart: Ferdinand Enke, 1905). Hirsch was director of the Grossherzogl. Kunst- und Gewerbeschule in Luxemburg.

19 Hermann Struck, *Die Kunst des Radierens*, 4th ed. (Berlin: Paul Cassirer, 1914), 194. Further evidence that feminists were branded masculine abberations, scourges to society, is offered in the misogynist writings of Otto Weininger, especially his influential book *Sex and Character*, published in 1903.

20 For an extended discussion of the series see: Alexandra von dem Knesebeck, " 'Der Volkskrieg dieser zeit hatte auch seine Heldinnen.' Zum Frauenbild der frühen Graphikfolgen," in *Käthe Kollwitz: Das Bild der Frau*, ed. Jutta Hülsewig-Johnen (Bielefeld: Kunsthalle, 1999), 59–71; and Hannelore Gärtner, "Käthe Kollwitz: Ein Neues Frauenbild als Gegenentwurf zu den Weiblichkeitsmythen des 19. Jahrhunderts," in *Frauen, Bilder, Männer, Mythen: Kunsthistorische Beiträge*, eds. Ilsebill Barta, Zita Breu, Daniela Hammer-Tugendhat, Ulrike Jenni, Irene Nierhaus and Judith Schöbel (Berlin: D. Reimer, 1987), 179–93.

21 Anna L. Plehn, "Die neuen Radierungen von Käthe Kollwitz," *Die Frau* 11 (1904): 234. Plehn describes the woman depicted in *Battlefield* (Black Anna) as the same figure seen from behind in *Outbreak*. Stefana Lesko investigates the political position of the journal *Die Frau* in her article "'Truly Womanly' and 'Truly German': Women's Rights and National Identity in *Die Frau*," in *Gender and Germanness: Cultural Productions of Nation*, eds. Patricia Herminghouse and Magda Mueller (Providence and Oxford: Berghahn Books, 1997), 129–44.

22 Alexandra von dem Knesebeck has suggested that *Woman and Dead Child* was initially conceived as the final sheet of the series but was later omitted, *Bild der Frau*, 65–66.

23 Plehn, "Die neuen Radierungen," 235.

24 Rosemary Betterton, *An Intimate Distance: Women, Artists and the Body* (London and New York: Routledge, 1996), 38–39.

25 Radycki, "The Life of Lady Art Students," 11.

26 Lily Braun, "The Female Mind," in *Selected Writings on Feminism and Socialism*, Alfred G. Meyer, ed. and trans. (Bloomington and Indianapolis: Indiana University Press, 1978), 180.

27 Karl Scheffler, *Die Frau und die Kunst: Ein Studie* (Berlin: Julius Bard, 1908), 78.

28 Roy F. Allen, *Literary Life in German Expressionism and the Berlin Circles* (Ann Arbor: UMI Press, 1983), chapter 6. My thanks to Mark Pascale and Matthias Mansen for their comments on the question of Kollwitz's "Expressionism."

29 For more on Kollwitz's internal struggle with the issue of artistic "style" and its relation to politics, see Prelinger, *Käthe Kollwitz*, 77–82.

30 For more on the issue of women Expressionists see: Alessandra Comini, "Gender or Genius? The Women Artists of German Expressionism," in *Feminism and Art History: Questioning the Litany*, eds. Norma Broude and Mary D. Garrard (New York: Harper and Row, 1982), 271–90; and Shulamith Behr, "Veiling Venus," 126–41.

31 Max Jungnickel, "Käthe Kollwitz," *Die Aktion*, no. 19 (1911): 587.

32 Ibid.

33 Ibid.

34 These articles suggest how a variety of authors championing diverse causes used Kollwitz's work to forward a range of ideological agendas from the Socialist journal *Sozialistische Monatshefte* to the bourgeois nationalist journal *Der Kunstwart*.

35 In 1893 Elias wrote a groundbreaking article on Kollwitz in the journal *Die Nation*.

36 Julius Elias, "Käthe Kollwitz," *Kunst und Künstler* 16 (1917): 540–42.

37 Ibid., 548–49. For more on Kollwitz's images of mothers, see: Gisela Schirmer, "Geschichte in der Verantwortung der Mütter: Von der Opferideologie zum Pazifismus," in *Bild der Frau*, 111–121; and Jula Dech, "Die Kollwitz-Mutter: Rädelsführerin und Mater dolorosa," in Renate Möhrmann ed., *Verklärt, verkitschst, vergessen? Die Mutter als ästhetische Figur* (Stuttgart: J. B. Metzler, 1996), 315–33. The issue of feminism and motherhood in Germany and its connections to Socialism and Social Democracy have been explored by Ann Taylor Allen in *Feminism and Motherhood in Germany, 1800–1914* (New Brunswick, N.J.: Rutgers University Press, 1991).

38 Alexandra von dem Knesebeck, *Käthe Kollwitz: Werkverzeichnis der Graphik* (Bern: Verlag Kornfeld, 2002), 39.

39 One author who fought against these reductive categories was Elizabeth McCausland. For more on her reception and support in America see: J. O. Schaefer, "The Kollwitz Konnection," *Women's Art Magazine* 62 (1995): 10–16; and Hildegard Bachert, "Collecting the Art of Käthe Kollwitz: A Survey of Collections, Collectors, and Public Response in Germany and the United States," in Prelinger, *Käthe Kollwitz*, 117–35.

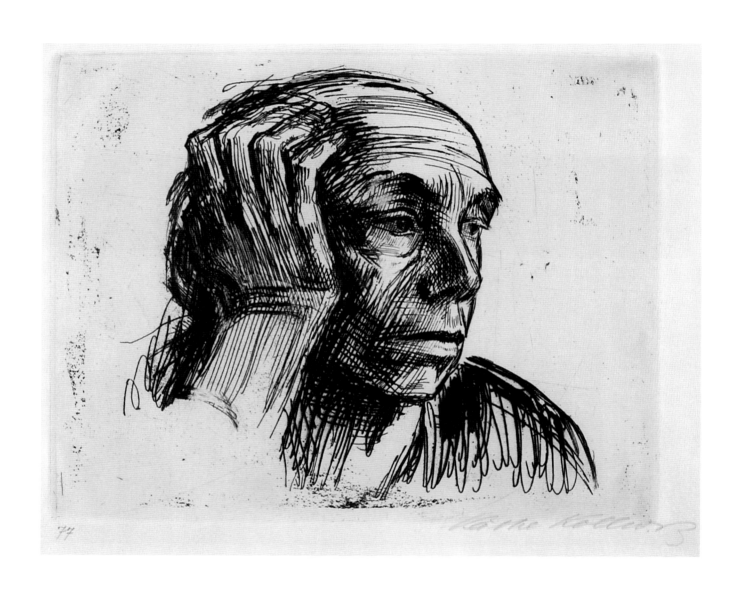

52

Self-Portrait
1921
Etching on laid paper
21.7 x 26.6 cm (imp.)
Private collection, Toronto

Chronology

1867
Born Käthe Schmidt 8 July in Königsberg, East Prussia.

1881–82
First art lessons with engraver Rudolf Maurer in Königsberg.

1884–86
Lives in Berlin, attends the Berlin Women's Art Union and studies with Swiss artist Karl Stauffer-Bern.

1884
Sees Max Klinger's print series *A Life* (Ein Leben) in Berlin.

1886
Studies with artist Emil Neide in Königsberg.

1888–89
Studies with artist Ludwig Heterich in Munich.

1890
Returns to Königsberg, makes first etchings.

1891
Marries Karl Kollwitz, a medical doctor, and moves to 25 Weissenburger Strasse in a working-class neighbourhood of Berlin.

1892
Birth of her son Hans.

1893
Attends performance of Gerhart Hauptmann's play *The Weavers*. Exhibits two prints in her first public exhibition at the Berlin Academy of Art. Exhibits three works at the Free Berlin Art Exhibition and receives her first critical acclaim.

1896
Makes first lithographs.
Birth of her son Peter.

1898
Nominated for a gold medal when the series *A Weavers' Rebellion* is shown at the Berlin Academy of Art Exhibition.
Appointed to a teaching position at the Berlin Women's Art Union.

1899
Begins to exhibit with the Berlin Secession, an independent art association.

1903
Receives commission from the Society for Historical Art for the series *Peasants' War*.

1904
Spends several weeks in Paris, studies sculpture at the Academy Julien in Paris, and visits the studio of sculptor Auguste Rodin.

1907
Wins the Villa Romana Prize and spends several months in Italy.

1909
Begins working in sculpture, and draws for the satirical magazine *Simplicissimus*.

1914
World War I breaks out and her son Peter is killed in Belgium.

1917
In celebration of her fiftieth birthday, several exhibitions of her work take place and notices appear in the press.

1919
Becomes first woman professor at the Berlin Academy of Art. Attends an exhibition of prints by Ernst Barlach and is inspired to make woodcuts.

1920s
Designs many posters for social causes.

1927
In celebration of her sixtieth birthday, several exhibitions take place and notices appear in the press. Travels to Moscow, where a major exhibition of her work is held.

1928
Made director of the graphics studio at the Berlin Academy of Art.

1932
Memorial to Peter, sculptures of the mourning parents, are installed in the military cemetery at Roggevelde, near Dixmuiden in Belgium.

1933
Following takeover of power by the National Socialists, forced to resign from the Berlin Academy of Art and loses teaching position, directorship and studio at the academy.

1934
Begins lithographs of *Death*, her last series.

1936
Threatened by the Gestapo with removal to a concentration camp. Unofficially prevented from exhibiting her work.

1939
Outbreak of World War II.

1940
Karl becomes ill, gives up his medical practice and dies on 19 July.

1942
Grandson Peter is killed in World War II.

1943
Evacuates to Nordhausen in the Harz Mountains, her apartment house in Berlin is destroyed along with printing plates and works of art.

1944
Invited by Prince Ernst Heinrich of Saxony to live in a small house near the Moritzburg Castle outside Dresden.

1945
Dies 22 April and is buried in the cemetery at Moritzburg.

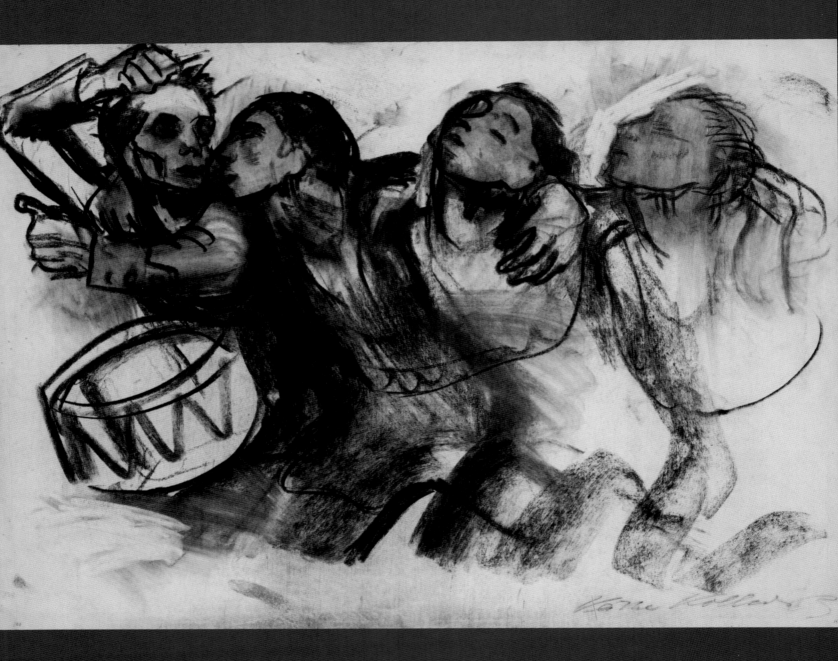

53

The Volunteers
1920
Study for sheet 2 of *War*
Charcoal on laid paper
49.3 x 70.0 cm
Graphische Sammlung, Staatsgalerie Stuttgart

A Personal Recollection

KÄTHE KOLLWITZ HAS BECOME AN ICON – almost more so abroad than in Germany – thanks to her consistent identification of life and art from the time of the empire through two world wars. Due to an experience that is still unforgotten after thirty-five years, I know that Kollwitz is also highly regarded in Canada. I am happy, therefore, to write on the occasion of the exhibition in Toronto about the origins of the Kollwitz collection in Stuttgart, which is particularly outstanding for its drawings.

On June 5, 1967, the Kollwitz collection of Salman Schocken, a German émigré to Israel, was auctioned in Hamburg. As the curator of the Stuttgart Collection, I was granted by our ministry DM 60,000, a large amount at that time. I believed I could acquire a great deal with this fund, but early on, the auction took a very different turn, and my heart sank. First, the dealer Eberhard Kornfeld from Bern, who was sitting in front of me, bid against me for an early self-portrait of Kollwitz from 1893. (He had previously acquired prints by her from the collection of another émigré, Erich Cohn of New York.) I breathed a sigh of relief when Kornfeld left the hall with his "treasure." But suddenly, strangers sitting behind me began to bid against me. Then lot no. 842, my favourite, came up for bidding, i.e., the large charcoal drawing of *The Volunteers* (cat. no. 53) of 1920, a vivid study for the woodcut series *War*. In memory of my fallen comrades in the Second World War, I bid blindly until I had it for 23,000. Swiss Franks. "Who were these counterbidders," I asked the auctioneer, Dr. Hauswedell in Hamburg, afterwards. "They are Canadians," he said. They had informed him that they still had to raise the money for the works bought at the auction. So even then, there were venturesome Kollwitz fans in this country!

The inducement to become engaged with Käthe Kollwitz in 1967 was her one hundredth birthday. (She was born on July 8, 1867, in Königsberg, East Prussia). I wanted to devote to this "portrayer of misery," as she was called in my youth, an exhibition worthy of her high artistic rank. The exhibition was also intended as a protest against the political investigation that the communist government subjected her to in the former East Germany, where there was a refusal to admit what Käthe Kollwitz had said in October 1920: "I long for socialism that lets people live.... The communist regime...cannot be the work of God" (cf. *Die Tagebücher*, edited by Jutta Bohnke-Kollwitz, Berlin, 1989, p. 483).

For my exhibition, it was not enough to have the four best-known print series, including *A Weavers' Rebellion*, from 1898, which established her early fame. Nor was it sufficient to have the handsome group of drawings that my predecessor, Erwin Petermann, had acquired after 1945 from the private collection of the Kollwitz family (as is stated in the 1960 catalogue of new acquisitions of nineteenth- and twentieth-century drawings – *Zeichnungen des 19. und 20. Jahrhunderts*). I was also moved by an early drawing that had come from the Hudtwalcker collection, *Sleeping Child and Child's Head* (cat. no. 23, illus. p.15) of 1903. In addition, my initiative was strengthened by the excellent Kollwitz drawings of the collector Dr. Helmut Beck, which were made available on loan. As a soldier on leave in 1943, Dr. Beck had acquired them directly from the artist, who had fled from Berlin to Nordhausen in the Harz Mountains.

The Stuttgart exhibition *Die Zeichnerin Käthe Kollwitz* (1967) presented ninety-eight drawings dating from 1889 to 1943 in a catalogue designed and produced by Walter Cantz. The catalogue began and ended with one of the artist's moving self-portraits. Quite apart from its success, the exhibition had far-reaching consequences for our collection.

The following year, the eldest son of the artist, Dr. Hans Kollwitz, M.D. (1892–1971), asked me to collaborate on his book *Ich sah die Welt mit liebevollen Blicken – Ein Leben in Selbstzeugnissen* (I Looked at the World with Love – A Life in Autobiographical Statements), by writing eight essays about his mother's drawings (Hanover, 1968, pp. 377–396). My connection with Hans's children, Jutta, Jördis and Arne, survived their father's death. They had visited Stuttgart for the opening of the 1967 exhibition, and, before the founding of the Kollwitz Museum in Cologne in 1986, they magnanimously gave us the opportunity to acquire other works from the estate. It is, above all, thanks to them that the print and drawing collection in the Staatsgalerie Stuttgart, today owns not only the four series of prints and the much sought-after and daring last lithograph of 1942, *Seed Corn Must Not Be Ground*, but also nearly forty choice drawings. And this now benefits the exhibition in Toronto. ■

Gunther Thiem
FORMER CURATOR OF PRINTS AND DRAWINGS (1963–1982)
STAATSGALERIE STUTTGART

List of Works in the Exhibition

The following catalogues raisonné of Kollwitz's prints and drawings were used:

August Klipstein, *Käthe Kollwitz: Verzeichnis des graphischen Werkes* (Bern/New York, 1955).

Alexandra von dem Knesebeck, *Käthe Kollwitz: Werkverzeichnis der Graphik*, 2 vols. (Bern: Verlag Kornfeld, 2002).

Otto Nagel and Werner Timm, *Käthe Kollwitz: Die Handzeichnungen* (Berlin, 1972).

Gunther Thiem, *Die Zeichnerin Käthe Kollwitz*, exhibition catalogue (Stuttgart: Staatsgalerie, Graphische, 1967).

1

Studienblatt mit 9 Frauenköpfen (Sheet of Head Studies (Women), 1890/91
NT 24, Thiem 7
Pen and ink and wash on laid paper
30.7 x 47.5 cm
Signed in graphite l.l.: *Kollwitz*
Signed in graphite mid.r.: *Käthe Kollwitz*
Graphische Sammlung, Staatsgalerie Stuttgart C77/2695
(illustrated on page 17)

2

Selbstbildnis, zeichnend im Halbprofil nach rechts (Self-Portrait, Drawn in Half-Profile to the Right), 1891/92
NT 31
Pen and black ink and wash over graphite on wove paper
20.4 x 14.1 cm
Inscribed in graphite l.r.: *wahrscheinlich/vor 1892* (probably before 1892)
Graphische Sammlung, Staatsgalerie Stuttgart C77/2693
(illustrated on page 18)

3

Studienblatt mit Details einer Stizenden (Studies of Details of a Seated Figure), c. 1890
NT 36
Pen and black ink and wash
16.8 x 29.9 cm
Inscribed in graphite: *Schmidt*
Graphische Sammlung, Staatsgalerie Stuttgart C77/2694

4

Königsberger Kneipe (Tavern in Königsberg), 1890/91;
Studies of women's clothing (verso)
NT 51
Pen and black ink and grey wash on wove paper
24.8 x 32.8 cm
Signed in graphite l.r.: *Käthe Kollwitz*
Art Gallery of Ontario, purchase, 1983 83/258
(illustrated on page 14)

5

Selbstbildnis am Tisch (Self-Portrait at a Table), 1893
Klipstein 14 iii(a)/v, Knesebeck 21 iii(c)/iv
Etching, drypoint, and aquatint on wove paper
17.8 x 12.8 cm (imp.)
Signed in graphite l.r.: *Käthe Kollwitz*
Signed in graphite l.l.: *O. Felsing*
Art Gallery of Hamilton, gift of Mr. G.C. Mutch in memory of his mother, Annie Elizabeth Mutch, 1959
(illustrated on page 19)

6

An der Kirchenmauer (At the Church Wall), 1893
Klipstein 19 v(a)/vi, Knesebeck 17 v/vii
Etching and drypoint on wove paper
24.9 x 13.2 cm (imp.)
Signed in graphite l.r.: *Kollwitz*
Private collection, Toronto
(illustrated on page 45)

7

Junges Paar (Young Couple), 1893
NT 84, Thiem 9
Charcoal on grey laid paper
43.0 x 55.0 cm (irregular)
Graphische Sammlung, Staatsgalerie Stuttgart GVL 35
(illustrated on page 22)

8

Beratung (Conspiracy), 1895
from *Ein Weberaufstand* (A Weavers' Rebellion)
(rejected as plate 3)
Klipstein 25 v/vii, Knesebeck 28 v/vii
Etching, drypoint, and sandpaper on cream wove paper
28.5 x 17.0 cm (imp.)
McMaster University Collection, Hamilton 1967.005.0001
(illustrated on page 47)

9

Weberzug (The Weavers' March), 1897
Plate 4 from *Ein Weberaufstand* (A Weavers' Rebellion)
Klipstein 32 ii/iv, Knesebeck 36 iii/v
Etching and sandpaper on cream wove paper
21.1 x 29.2 cm (imp.)
Signed in graphite l.r.: *Käthe Kollwitz*
Collection of Ramsay and Eleanor Cook
(illustrated on page 46)

10

Sturm (Storming the Gate), 1897
Plate 5 from *Ein Weberaufstand* (A Weavers' Rebellion)
Klipstein 33 ii(b)/v, Knesebeck 37 iib/v
Bound into "offprint" of essay by Werner Weisbach from *Zeitschrift für bildende Kunst*, vol. 16, no. 4, 1905
Etching and sandpaper on cream wove paper
23.8 x 29.5 cm (imp.)
Private collection, Toronto
(illustrated on page 48)

11

Ende (End), 1897
Plate 6 from *Ein Weberaufstand* (A Weavers' Rebellion)
Klipstein 37iii/v, Knesebeck 38 iii/v
Etching, aquatint and sandpaper on cream wove paper
23.6 x 30.0 cm (imp.)
McMaster University Collection, Hamilton 1967.004.0001
(illustrated on page 24)

12

Frau an der Wiege (Woman at the Cradle), 1897
Klipstein 38 iii(d)/iii, Knesebeck 40 v(a)/vi
Etching, drypoint, and sandpaper on laid paper
27.6 x 14.5 cm (imp.)
Collection of Raymond and Yolanda Burka

13

Aufruhr (Uprising), 1899
Klipstein 44 vii/viii, Knesebeck 46 vii/ix
Etching, drypoint, aquatint, sandpaper and roulette on wove paper
29.5 x 31.5 cm (imp.)
Signed in graphite l.r.: *Kollwitz*
Art Gallery of Ontario, gift of W. Gunther and Elizabeth S. Plaut, 1995 95/341
(illustrated on page 57)

14
Selbstbildnis und Aktstudien (Self-Portrait
with Nude Studies), 1900
NT 167, Thiem 17
Pen and black ink with wash over graphite
heightened with white on brown paper
28.0 x 44.5 cm (irregular sheet)
Signed and inscribed l.r.: *Käthe
Kollwitz/Martha Schwann, Lothring 44*
Graphische Sammlung, Staatsgalerie
Stuttgart GL462
(illustrated on page 12)

15
Kniender Mann vor weiblichem Rückenakt
(Man Kneeling before a Female Nude Seen
from behind), c. 1900
NT 169
Charcoal and blue chalk heightened with
white
64.0 x 50.1 cm
Graphische Sammlung, Staatsgalerie
Stuttgart C77/2700
(illustrated on page 16)

16
Das Leben (Life), 1900
NT 158, Thiem 16
Left: pen and black ink and wash heightened
with white on white laid paper; Centre: black
chalk over graphite with grey wash on white
laid paper; Right: black chalk and graphite
with pen and black ink and wash on brown
paper
32.5 x 92.9 cm
Signed l.r.: *Kollwitz*
Inscribed l. centre: *DAS LEBEN*
Graphische Sammlung, Staatsgalerie
Stuttgart C71/2138
(illustrated on page 26)

17
Zertretene – Arme Familie (The
Downtrodden), 1900
Klipstein 48 ivA2c/iv, Knesebeck 49bis
iiB(d)/ii
Etching, drypoint, and aquatint on wove
paper
23.8 x 19.5 cm (imp.)
Published in *Zeitschrift für bildende Kunst*,
vol. 20, no. 8, 1909
McMaster University Collection, Hamilton
1971.025.0001

18
*Zertretene – Leichnam und Frauenakt am
Pfahl* (The Downtrodden), 1900
Klipstein 48 ivB2/iv, Knesebeck 49ter b/c
Etching, drypoint and aquatint on wove
paper
23.8 x 62.8 cm (imp.)
Gift of Dr. and Mrs. D.M. Shaw, McMaster
University Collection, Hamilton
2000.002.0003

19
Die Carmagnole (The Carmagnole), 1901
Klipstein 49 v/viii, Knesebeck 51 v(c)/ix
Etching, drypoint, aquatint and sandpaper
on wove paper
57.8 x 45.0 cm (imp.)
Signed in graphite l.r.: *Käthe Kollwitz*
Art Gallery of Ontario, purchase, 1983
83/257
(illustrated on page 25)

20
Pflugzieher (Pulling the Plough), c. 1902
NT 197, Thiem 21
Charcoal on grey laid paper
61.5 x 47.5 cm
Signed l.r. in graphite: *Kollwitz*
Graphische Sammlung, Staatsgalerie
Stuttgart C77/2696
(illustrated on page 50)

21
Studie zu "Pflugzieher" mit kniender Frau
(Study to *Pulling the Plough* with Kneeling
Woman); *Kinderstudien* (Studies of
Children) (verso), c. 1902
NT 199
Charcoal on grey laid paper
47.2 x 62.4 cm
Signed l.r. in graphite: *Kollwitz*
Graphische Sammlung, Staatsgalerie
Stuttgart C77/2697

22
Kopf und Hände eines schlafenden Knaben
(Head and Hands of a Sleeping Boy); Two
Head Studies of a Woman Sleeping for
"Pieta" (verso), 1903
NT 235, Thiem 24
Charcoal over graphite on wove paper
48.0 x 63.0 cm
Signed and inscribed in graphite:
Kollwitz...Freitag 1 St. Georg Lehmann
Graphische Sammlung, Staatsgalerie
Stuttgart GVL 46
(illustrated on page 32)

23
Schlafender Knabe und Kopfstudie
(Sleeping Child and Child's Head), 1903
NT 256, Thiem 23
Charcoal, pen and black ink, green pastel,
white highlights on grey-brown paper
51.0 x 63.0 cm
signed l.r.: *Kollwitz*
Graphische Sammlung, Staatsgalerie
Stuttgart C60/931
(illustrated on page 15)

24
Losbruch (Outbreak), 1903
Plate 5 from *Bauernkrieg* (Peasants' War)
Klipstein 66 x/xi, Knesebeck 70 xi/xiii
Etching, drypoint, soft-ground and aquatint
on wove paper
50.8 x 59.4 cm (imp.)
Signed in graphite l.r.: *Käthe Kollwitz,
Bauernkrieg Bl. 5.*
Signed in graphite l.l.: *O Felsing*
Art Gallery of Ontario, gift of W. Gunther
and Elizabeth S. Plaut, 1995 95/342
(illustrated on page 27)

25
Brustbild einer Arbeiterfrau mit blauem Tuch
(Working Woman with Blue Shawl), 1903
Klipstein 68iii(b)/iii, Knesebeck 75iii(b) /iii
Colour lithograph on wove paper
35.6 x 24.5 cm (comp.)
Collection of Ramsay and Eleanor Cook
(illustrated on page 56)

26
Frau mit Totem Kind (Woman with Dead
Child), 1903
NT 242, Thiem 26
Charcoal over red chalk, heightened with
white on wove paper
46.5 x 56.5 cm
Signed in graphite l.r.: *Käthe Kollwitz*
Graphische Sammlung, Staatsgalerie
Stuttgart C67/1480
(illustrated on page 54)

27
Frau mit Totem Kind (Woman with Dead
Child), 1903
Klipstein 72 ix/x, Knesebeck 81 ix/x
Etching, drypoint, sandpaper and soft-
ground on wove paper
42.1 x 48.2 cm (imp.)
Signed in graphite l.r.: *Käthe Kollwitz*
Art Gallery of Ontario, purchase, 1965
64/50
(illustrated on page 55)

28
Halbfigur eines Hingestreckten (Half-Figure
Outstretched), c. 1903–05
NT 263, Thiem 27
Charcoal on brown paper
33.0 x 59.0 cm (irregular sheet)
Signed in graphite l.r.: *Käthe Kollwitz*
Graphische Sammlung, Staatsgalerie
Stuttgart C67/1483

29
Inspiration, 1904/05
NT 293, Thiem 36
Charcoal with graphite on grey paper
36.6 x 25.7 cm
Signed in graphite l.r.: *Käthe Kollwitz*
Graphische Sammlung, Staatsgalerie
Stuttgart C67/1481

30
Auf den Fersen sitzender weiblicher Akt
(Female Nude Seated on Her Heel), c. 1904
NT 310, Thiem 31
Charcoal on grey laid paper
63.0 x 48.0 cm
Signed in graphite l.r.: *Kollwitz*
Graphische Sammlung, Staatsgalerie
Stuttgart C58/824

31
Junges Paar (Young Couple), 1904
Klipstein 73 iv/v, Knesebeck 83 iv/v
Etching and soft-ground on wove paper
29.8 x 31.6 cm (imp.)
Inscribed in graphite l.r.: *Kollwitz*
l.l.: *1912*
Collection of David and Anita Blackwood
(illustrated on page 23)

32
Gesenkter Frauenkopf (Woman with Head
Bent), 1905
Klipstein 77 iv/v, Knesebeck 94 iv/vi
Etching, drypoint, soft-ground and roulette
on wove paper
37.9 x 31.8 cm (imp.)
Signed in graphite l.r.: *Kollwitz*
Art Gallery of Ontario, gift of W. Gunther
and Elizabeth S. Plaut, 1995 95/343

33
Beim Dengeln (Sharpening the Scythe),
1905
Plate 3 from *Bauernkrieg* (Peasants' War)
Klipstein 90 ix/xii, Knesebeck 88 x(b)/xiv
Etching, drypoint, aquatint, sandpaper and
soft-ground on wove paper
29.4 x 29.4 cm (imp.)
Signed in graphite l.l.: *Käthe Kollwitz*
Art Gallery of Ontario, gift of W. Gunther
and Elizabeth S. Plaut, 1995 95/344
(illustrated on page 52)

34
Die Pflüger (The Plowers), 1906
Plate 1 from *Bauernkrieg* (Peasants' War)
Klipstein 94 vii/ix, Knesebeck 99 xi/xiii
Etching, drypoint, aquatint, sandpaper and
soft-ground on wove paper
31.1 x 45.3 cm (imp.)
Signed in graphite l.r.: *Käthe Kollwitz*
Bauernkrieg Bl. 1
Signed in graphite l.l.: *O. Felsing*
Art Gallery of Ontario, gift of W. Gunther
and Elizabeth S. Plaut, 1995 95/345
(illustrated on page 51)

35
Bewaffnung in einem Gewölbe (Arming in a
Vault), 1906
Plate 4 from *Bauernkrieg* (Peasants' War)
Klipstein 95 vii/ix, Knesebeck 96 viii(b)/x
Etching, drypoint, aquatint and soft-ground
on laid paper
47.5 x 31.4 cm (imp.)
Signed in graphite l.r.: *Käthe Kollwitz*
McMaster University Collection, Hamilton
1969.003.0001

36
Schlachtfeld (Battlefield), 1907
Plate 6 from *Bauernkrieg* (Peasants' War)
Klipstein 96 x/xii, Knesebeck 100 xi(b)/xv
Etching, drypoint, aquatint, sandpaper with
plate tone and engraving on laid paper
39.5 x 51.4 cm (imp.)
Signed in graphite l.r.: *Käthe Kollwitz*
McMaster University Collection, Hamilton
1971.026.0001

37
Vergewaltigt (Raped), 1907
Plate 2 from *Bauernkrieg* (Peasants' War),
1907
Klipstein 97 vi/viii, Knesebeck 101 vi(b)/viii
Etching, drypoint, sandpaper and soft-
ground on laid paper
30.2 x 52.0 cm (imp.)
Signed in graphite l.r.: *Käthe Kollwitz*
Signed in graphite l.l.: *O Felsing*
McMaster University Collection, Hamilton
1967.016.0001
(illustrated on page 53)

38
Peter zu Gefangenen (Study of Peter for
"Prisoners"), 1908
NT 437, Thiem 40
Graphite on brown paper
46.9 x 65.5 cm
Inscribed in graphite l.l.: *Peter zu*
Gefangenen
Graphische Sammlung, Staatsgalerie
Stuttgart C77/2698
(illustrated on page 27)

39
Die Gefangenen (The Prisoners), 1908
Plate 7 from *Bauernkrieg* (Peasants' War)
Klipstein 98 vi/viii, Knesebeck 102 viii/x
Etching, drypoint, sandpaper and soft-
ground on wove paper
32.4 x 42.1 cm (imp.)
Signed in graphite l.r.: *Käthe Kollwitz*
Bauerkrieg Bl.7
Signed in graphite l.l.: *O. Felsing*
Art Gallery of Ontario, gift of W. Gunther
and Elizabeth S. Plaut, 1995 95/346
(illustrated on page 27)

40
Kohlenstreik (Coal Miners' Strike), c. 1910
NT 556, Thiem 43
Charcoal with white heightening on grey
wove paper
65.5 x 47.0 cm
Signed in graphite l.r.: *Käthe Kollwitz*
Graphische Sammlung, Staatsgalerie
Stuttgart C67/1485

41
Tod und Frau (Death and Woman), 1910
Klipstein 103 vii/viii, Knesebeck 107vii/viii
Etching, drypoint, sandpaper, soft-ground
and roulette on wove paper
44.7 x 44.6 cm (imp.)
Collection of Barry Callaghan and Nina
Callaghan
(illustrated on page 34)

42
Schwangere Frau (Pregnant Woman), 1910
Klipstein 108 v/vi, Knesebeck 111 v/vii
Etching, drypoint, aquatint and soft-ground
on wove paper
37.2 x 23.3 cm (imp.)
Signed in graphite l.r.: *Kollwitz*
Art Gallery of Ontario, gift of W. Gunther
and Elizabeth S. Plaut, 1995 95/347
(illustrated on page 58)

43
Am Boden sitzende Frau (Woman Seated on
the Ground), 1910/11
NT 623, Thiem 30
Charcoal on greenish grey paper
46.8 x 65.5 cm
Graphische Sammlung, Staatsgalerie
Stuttgart C58/823
(illustrated on page 17)

44
Tod entreisst einer Mutter das Kind (Death
Tearing Child from Its Mother), c. 1911
NT 643, Thiem 51
Black chalk and charcoal on grey laid paper
63.0 x 47.9 cm
signed in graphite l.r.: *Käthe Kollwitz*
Graphische Sammlung, Staatsgalerie
Stuttgart C77/2699
(illustrated on page 42)

45
Mutter am Bett des toten Kindes (Mother at
the Bed of Her Dead Child); *Sitzende Akte*
(Seated Nudes) (verso), 1911
NT 653, Thiem 52
Charcoal on laid paper
48.0 x 56.0 cm
Signed in graphite l.r.: *Käthe Kollwitz*
Graphische Sammlung, Staatsgalerie
Stuttgart GVL 40

46
Weibergefängnis (Women's Prison), 1912
NT 694, Thiem 53
Charcoal on laid paper
48.0 x 63.0 cm
Signed and inscribed in graphite l.r.:
Kollwitz/Weibergefängnis
Graphische Sammlung, Staatsgalerie
Stuttgart GVL 44

47
Selbstbildnis (Self-Portrait), 1912
Klipstein 122 iv(e)/iv,
Knesebeck 126 vii(d)3/vii
Etching, drypoint and soft-ground on wove
paper
14.1 x 10.0 cm (imp.)
Inscribed in graphite l.r.: *Kollwitz*
l.l.: *1912*
Collection of David and Anita Blackwood

48
Das Warten (Das Bangen) (Waiting [Fear])
Published in *Kriegzeit* no. 10, 1914
Klipstein 126 iib, Knesebeck 132 iib
Transfer lithograph on wove paper
34.0 x 24.5 cm (comp.)
Art Gallery of Ontario, gift of Dr. Naomi
Jackson Groves, 1992 93/393.4

49
Mütter (Mothers), 1919
Klipstein 135 ii/ii, Knesebeck 140 ii/ii
Transfer lithograph on wove paper
52.2 x 62.9 cm (sheet)
Signed in the image and in graphite l.r.:
Käthe Kollwitz ... Mutter
Art Gallery of Ontario, gift of W. Gunther
and Elizabeth S. Plaut, 1995 95/348
(illustrated on page 10)

50
Gedenkblatt für Karl Liebknecht (Memorial
Sheet to Karl Liebknecht), 1919/20
Klipstein 139 iva/iv, Knesebeck 159 vi(a)/vi
Woodcut on wove paper
35.3 x 49.4 cm (comp.)
Signed in graphite l.r.: *Käthe Kollwitz*
Inscribed: *DIE LEBENDEN DEM TOTEN
ERINNERUNG AN DEN 15. JANUAR 1919*
(In living memory of the murder on
January 15, 1919)
Collection of Ronald and Maralyn Biderman
(illustrated on page 28)

51
Nachdenkende Frau (Thinking Woman),
1920
Klipstein 147 i(a)/ii, Knesebeck 160 iii/iii
Transfer lithograph on wove paper
59.8 x 44.3 cm (sheet)
Signed in graphite l.l.: *Käthe Kollwitz*
Art Gallery of Ontario, gift of Carol and
Morton Rapp, 2002
(illustrated on page 19)

52
Selbstbildnis (Self-Portrait), 1921
Klipstein 155 vi(b)/vi, Knesebeck 171 vi(c)/vi
Etching on laid paper
21.7 x 26.6 cm (imp.)
Signed in graphite l.r.: *Käthe Kollwitz*
Inscribed in graphite l.l.: 77
Private collection, Toronto
(illustrated on page 62)

53
Die Freiwilligen (The Volunteers), 1920
Study for sheet 2 of *War*
NT 850, Thiem 59
Charcoal on laid paper
49.3 x 70.0 cm
Signed in graphite l.r.: *Käthe Kollwitz*
Graphische Sammlung, Staatsgalerie
Stuttgart C67/1482
(illustrated on page 64)

54
Die Witwe I (The Widow I), 1920
Klipstein 160a (proof), Knesebeck 152 a
(proof)
Lithograph on wove paper
Printed on verso of Max Pechstein poster
(1919) for the December exhibition of Fritz
Gurlitt
45.3 x 36.0 cm (irregular sheet)
Art Gallery of Ontario, gift from the
collection of Rose and Louis Melzack, 1989
91/378
(illustrated on page 30)

55
Das Opfer (The Sacrifice), 1922
Sheet 1 from *Krieg* (War)
Klipstein 177 vii(c)/vii, Knesebeck 179
ix(d)/ix
Woodcut on brown wove paper (printed from
an electrotype plate)
37.0 x 40.0 cm (comp.)
Inscribed in graphite l.r.: *Käthe Kollwitz*
Art Gallery of Ontario, gift from the collec-
tion of Rose and Louis Melzack, 1989
89/396
(illustrated on page 31)

56
Die Witwe II (The Widow II), 1922
Sheet 5 from *Krieg* (War)
Klipstein 181 vii(c)/vii, Knesebeck 178
vii(c)/vii
Woodcut on wove paper
30.0 x 52.0 cm
Signed in graphite l.r.: *Käthe Kollwitz*
Inscribed l.l.: *B 1/100 and Die Witwe II*
Gift of Dr. Douglas Davidson; Associated
American Artists
McMaster University Collection, Hamilton
1987.006.0003

57
Das Volk (The People), 1922
Sheet 7 from *Krieg* (War)
Klipstein 183 v(c)/v, Knesebeck 190 vii(d)/vii
Woodcut on brown wove paper (printed from
an electrotype plate)
36.0 x 30.0 cm (comp.)
Inscribed in graphite l.r.: *Käthe Kollwitz*
Art Gallery of Ontario, gift from the
collection of Rose and Louis Melzack, 1989
89/397

58
*Stehende Frau, Die das vor ihr Stehende Kind
mit Beiden Händen an sich Presst* (Standing
Woman Clutching Child), c. 1924
Seated Nude from the back (verso)
NT 1013
Charcoal on tan laid paper
48.3 x 32.2 cm
Signed in graphite l.r.: *Kollwitz*
Private collection, Toronto
(illustrated on page 20)

59
Stehende Frau mit Kind (Standing Woman
with Child), 1924
NT 1030, Thiem 75
Pen and black ink and wash on laid paper
48.5 x 28.5 cm
Signed in graphite l.r.: *Käthe Kollwitz*
Graphische Sammlung, Staatsgalerie
Stuttgart C50/155
(illustrated on page 6)

60
Nie wieder Krieg! (Never Again War!),
1923/24
NT 1038, Thiem 70
Charcoal on grey paper
65.0 x 50.0 cm
Inscribed l.l.: *Nie wieder Krieg*
Signed in graphite l.r.: *Kollwitz*
Graphische Sammlung, Staatsgalerie
Stuttgart GVL 41
(illustrated on cover)

61
Selbstbildnis (Self-Portrait), 1924
Klipstein 202 v/vii, Knesebeck 203 vi(a)/vi
Woodcut on wove paper
20.8 x 30.0 cm
Signed in graphite l.r.: *Kollwitz*
McMaster University Collection, Hamilton
1969.004.0001

62
Umarmung (Embrace), c. 1924/25
NT 1045, Thiem 78
Charcoal on laid paper
64.0 x 48.5 cm
Signed in graphite l.r.: *Kollwitz*
Graphische Sammlung, Staatsgalerie
Stuttgart GVL 48
(illustrated on page 48)

63
Heimarbeit (Home Worker), 1925
NT 1074, Thiem 76
Lithographic crayon on wove paper
53.0 x 39.0 cm
Signed in graphite l.r.: *Kollwitz*
Graphische Sammlung, Staatsgalerie
Stuttgart GVL 36

64
Städtisches Obdach (Municipal Shelter),
1926
NT 1112, Thiem 80
Charcoal on laid paper
60.0 x 45.0 cm
Signed and inscribed in graphite l.r.: *Käthe
Kollwitz/Stadtisches Obdach*
Graphische Sammlung, Staatsgalerie
Stuttgart GVL 42
(illustrated on page 29)

65
Städtisches Obdach (Municipal Shelter),
1926
Klipstein 219 b (B), Knesebeck 226 c
Transfer lithograph on laid paper
48.3 x 66.0 cm (irregular sheet)
Art Gallery of Ontario, gift of W. Gunther
and Elizabeth S. Plaut, 1995 95/349
(illustrated on page 29)

66
Maria und Elisabeth (Mary and Elizabeth),
1926/27
Lotte (verso)
NT 1130, Thiem 83
Charcoal on cream paper
38.5 x 50.5 cm
Signed in graphite l.r.: *Käthe Kollwitz*
Graphische Sammlung, Staatsgalerie
Stuttgart GVL 38
(illustrated on page 21)

67
Mutter mit Kind auf dem Arm (Mother with
Child in Her Arms), 1931/32
NT 1219, Thiem 89
Charcoal on brown laid paper
63.0 x 49.0 cm
Signed and inscribed in graphite l.r.:
Kollwitz/L.D. mit Helmut
Graphische Sammlung, Staatsgalerie
Stuttgart GVL39
(illustrated on page 20)

68
Selbstbildnis (Self-Portrait), 1934
Klipstein 252b, Knesebeck 263b
Transfer lithograph on wove paper
37.4 x 26.9 cm (sheet)
Signed and dated in graphite l.r.: *Käthe
Kollwitz 1934*
National Gallery of Canada, Ottawa, pur-
chase, 1961

69
Tod Greift in Kinderschar (Death with
Frightened Children), 1934
Sheet 3 from *Tod* (Death)
Klipstein 258 b, Knesebeck 266 ii(b)/ii
Lithograph on wove paper
50.0 x 42.0 cm (comp.)
Signed in graphite l.r.: *Käthe Kollwitz*
Inscribed in graphite l.l.: *3/100*
Collection of Barry Callaghan and Claire
Weissman Wilks

70
Frau vertraut sich dem Tod an (Woman
Entrusting Herself to Death); *Figurenstudie*
(Figure Studies) (verso), 1934
NT 1265, Thiem 93
Charcoal on grey paper
62.8 x 47.0 cm
Signed in graphite l.r.: *Käthe Kollwitz*
Graphische Sammlung, Staatsgalerie
Stuttgart GVL49

71
Ruf des Todes (Call of Death), 1934/35
Sheet 8 from *Tod* (Death)
Klipstein 263c, Knesebeck 269c
Lithograph on wove paper
38.0 x 38.3 cm (comp.)
Inscribed in graphite l.r.: *Aus dem nachlass
Käthe Kollwitz/Hans Kollwitz*
Collection of Mark and Judy McLean
(illustrated on page 39)

72
Grabrelief (Ruht im Frieden seiner Hände)
(Resting in the Peace of His Hands), c. 1935
Terracotta
35.5 x 31.5 x 10.0 cm
Inscribed l. centre: *KOLLWITZ*
Levy Bequest purchase, McMaster
University Collection, Hamilton
(illustrated on page 38)

73
Selbstbildnis im Profil nach Rechts (Self-
Portrait in Profile to the Right), 1938
Klipstein 265 iiia/iii, Knesebeck 273 iii(c)/iii
Lithograph on wove paper
75.0 x 50.0 cm (sheet)
Inscribed in graphite l.r.: *Aus dem Nachlass
Käthe Kollwitz/Hans Kollwitz*
National Gallery of Canada, Ottawa, gift of
Mr. S. Muhlstock, Montreal, 1964

74
Pietà, 1938
Bronze
36.8 x 28.0 x 39.1 cm
Inscribed: *Kollwitz*
Foundry mark: *H. Noack, Berlin*
National Gallery of Canada, Ottawa,
purchase, 1963

75
Die Klage (Lamentation: In Memory of Ernst
Barlach), 1938
Bronze
26.5 x 25.7 x 10.2 cm
Inscribed: *Kollwitz*
Foundry mark: *H. Noack, Berlin*
Art Gallery of Ontario, gift from the Junior
Women's Committee Fund, 1963 62/36
(illustrated on page 36)

76
Abschied (Farewell), 1940/41
Bronze
17.4 x 11.1 x 11.4 cm
Signed: *KK*
Foundry mark: *H. Noack, Berlin*
Private collection, Toronto
(illustrated on page 35)

77
Zwei wartende Soldatenfrauen (Two Waiting
Soldiers' Wives), 1943
Bronze
22.5 x 25.0 x 20.5 cm
Inscribed: *Kollwitz*
Foundry mark: *H. Noack, Berlin*
Collection of Dr. Louis Myers
(illustrated on page 37)

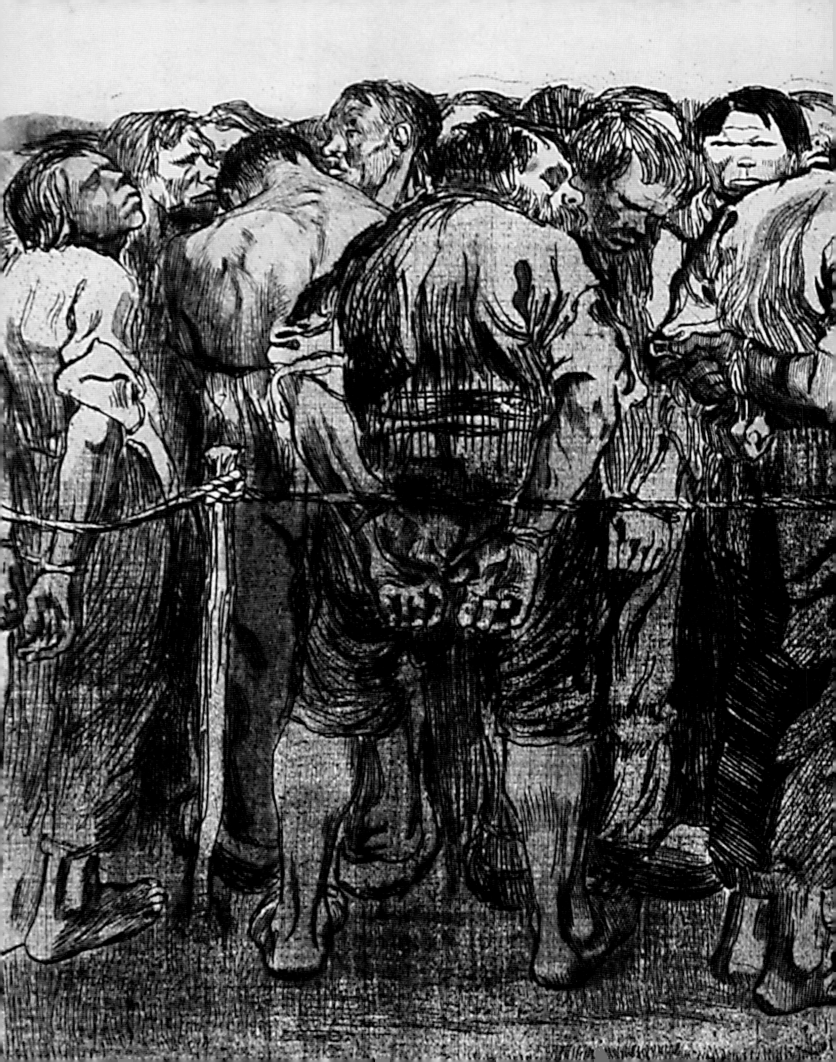